THE EVOLUTION & HISTORY OF
MOOSEKIND

THE EVOLUTION & HISTORY OF
MOOSEKIND

CREATED, WRITTEN AND ILLUSTRATED BY
BOB FOSTER

FANTAGRAPHICS BOOKS

FANTAGRAPHICS BOOKS, INC.
1800 Bridgegate Street Suite 101
Westlake Village, California 91361

Design and production by Roberta Gregory
Gary Groth and Kim Thompson, Publishers

First Fantagraphics Books edition: March, 1989.

1 2 3 4 5 6 7 8 9 10

ISBN: 0930193-96-2

LOVE AND ANTLERS
A SERIOUS DISSERTATION

by Marv Wolfman

I can't tell you exactly when I first became moose-crazy. Frankly, I don't remember. Frankly, I don't even care to remember. But I do remember always finding mooses among the most ridiculous-looking animals that ever existed. They are totally non-cuddly, non-attractive, non-friendly, and non-sense. I just know that somewhere in the deep recesses of my childhood, when other kids were selecting frogs or bears or cows as the animal they'd "collect," I decided to collect mooses.

Perhaps it began with Bullwinkle, but don't hold me to that. I do remember loving the *Rocky and Bullwinkle* show. Or the *Bullwinkle* show that followed that, but I don't remember if I gravitated to that show because of my life-long interest in mooses or I began moose studies because of that show. Frankly, who cares?

So there I was, moose-crazy, young and free, attending a comics convention when, from the corner of my eye, I saw a small magazine sticking out from one of the comics racks. Its title was *Myron Moose Funnies*, and the cover showed a picture of a moose with a running nose. Eagerly, I bought the magazine. Was this nirvana, thought I? Was this what I have been seeking for lo those many years?

No, but it was funny anyway. The jokes, written and drawn by something named Bob Foster (whose name I vaguely remembered) consisted of little more than this strangely-drawn moose with a running nose. Definitely high character comedy. There was a several page section where Mr. Foster replicated the origins of several well-known comic book characters, only inserting mooses in the real character's position. Not funny by any logical standard, but somehow hilarious nonetheless.

Dissolve To:

I am now at Marvel Comics and have been given the unenviable job of beginning a humor magazine that would be called *Crazy*. Now, I was instructed to do a *MAD/Cracked*-type of magazine, but I decided to do something different. I wanted *Crazy* to be positioned someplace between *MAD* and *National Lampoon*. More satiric than *MAD*, less gross than *Lampoon*.

I had six weeks to put together the first issue. Six weeks and almost no budget. I had to come up with a format, find artists and writers (I wasn't allowed to use much of the Marvel stable), figure out what the editorial slant of the magaine would be, and actually get the material together. *Not* an easy task because *Crazy* was only one of several magazines I was assigned to edit.

I had in mind something strange as a continuing feature. Something very strange. And then I remembered *Myron Moose*. I scrambled though my old collection and found the comic, but there was no hint in it as to the location of this Bob Foster (whose name still sounded vaguely familiar).

I began looking at other old magazines and was thumbing through *Fantasy Illustrated*, a wonderfully produced SF/Fantasy fanzine of the 1960s. In it I found a cartoon by...Bob Foster.

I called around and got the phone number for *Fantasy Illustrated*'s publisher and editor, Bill Spicer. Through Bill I got Bob Foster's phone number. And then I called Bob.

I introduced myself and told Bob how much I had enjoyed *Myron Moose*. Myron, it seems, must have sold three copies because Bob was astonished that anyone had ever seen the magazine, let alone bought and liked it. Let alone anyone on the East coast, as Bob lived in Los Angeles. It took awhile to convince him the phone call was real and that I actually wanted to pay him (albeit badly) to do more moose work for me.

But what to do? Bob suggested more *Myron Moose*, but I indicated if he did that Marvel would probably own the copyright, so let's come up with something new, different, and equally dumb. I think I may have

suggested doing *The History of Moosekind*—a satirical version of our own history, but don't hold me to it.

Bob had an assignment, and I waited while assembling the rest of the magazine. **And waited.**

And waited.

And called Bob.

And waited some more.

And I think 11 minutes before we had to ship the first issue, *History* made it to the Marvel offices. I eagerly opened the package and gave a sigh of relief. Not only had Bob written and drawn the entire story, but he typeset it too. There'd be no delay in sending out the work. I only prayed it was funny.

It wasn't, but then, what of Bob Foster's work is?

Actually, seriously, *The History of Moosekind* was a hilarious send-up of history—absolutely accurate in its own bizarre fashion, and a constant delight...if only it had ever been sent on time.

What Bob did with *History* was amazing, and rather than just extoll its virtues (and make Bob feel lousy since he hasn't done anything this good since), I'll just say read the book and enjoy its subtlety, intelligence, and wackiness.

And always remember when going into a restaurant—order a table for 26 because you'll all want to sit on the same side.

—*Marv Wolfman*
6-22-88

WRITER/ARTIST:
BOB FOSTER

EVOLUTION
AND HISTORY OF
MOOSEKIND

**The cloak of obscurity surrounding the geneology of Moose is being lifted.
Recent findings reveal Moosekind's true role in the Evolutionary Process.**

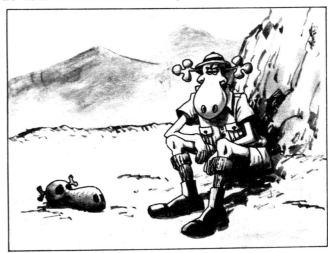

CLIMAX OF A THIRTY YEAR PROBE
which began in 1943. Dr. Melville Moose
displays skull and proboscis fragments of
MOOSO HABILIS which he unearthed last
month while engineering the groundwork
and construction of native disposal
facilities.

MODERN MOOSE

**CRO-MAGNON
MOOSE**
30,000 years ago

**NEANDERTHAL
MOOSE**
100,000 years ago

PEKING MOOSE
300,000 years ago

JAVA MOOSE
500,000 years ago

PILTDOWN MOOSE
1 million years ago

MOOSO HABILIS
1.8 million years ago

A thirty year probe into the origins of Moosekind
reached a dazzling climax recently when Dr. Mel-
ville Moose, noted anthropologist, paleontologist and
rock-hound, revealed skull and proboscis fragments
of **MOOSO HABILIS,** believed to be the earliest
known direct ancestor of modern Moose (**MOOSO
SAPIENS**).

In light of this new evidence, Dr. Moose concludes
that Moose were the first cave-dwellers and that
MOOSO HABILIS was undoubtedly responsible for
creation and development of both fire and the wheel.
Dr. Moose presents conclusive evidence to substan-
tiate these findings in the form of descriptive cave-
paintings, tell-tale ashes and a small cache of pre-
historic flint-head matches.

"These new findings make all existing work on pre-
historic Moose obsolete," said Dr. Moose at a news
conference held recently in Washington. Next month,
Dr. Moose returns to his work convinced that he will
further push back the horizons of Moosekind.

**Prehistoric match
leads Dr. Moose
to believe that
MOOSO HABILIS
knew of fire. ➔**

Scale 1" = 1"

FIRST PREHISTORIC FIND for the future Dr. Moose occurred at the age of 20, while doing some exploratory digging in his basement. With him is Mrs. Moose, who disappeared shortly after this photo was taken in 1943.

CAVE PAINTINGS depict objects that Dr. Moose describes as "having significant value in strengthening my conclusions that **MOOSO HABILIS** developed a crude but functional circular object that could be the predecessor to the modern wheel.

A SECOND significant discovery was made by Dr. Moose in 1949 at the location of his first excavation of six years earlier. With him is his second wife, Myrna. Before them are the skull and proboscis bones of a female **Cro-Magnon Moose.**

"MOOSE HAD his origins in the sea, the acknowledged birthplace of all contemporary life-forms," says Dr. Moose. The illustrations below depict various stages in Moose's evolution from sea-life to Moose.

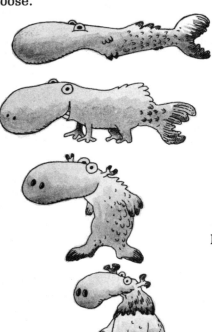

◄SOME KEY STAGES in the evolution of Moosekind, reconstructed from fossil remains.

An artist's concept of a day in the life of a cave Moose ——▶

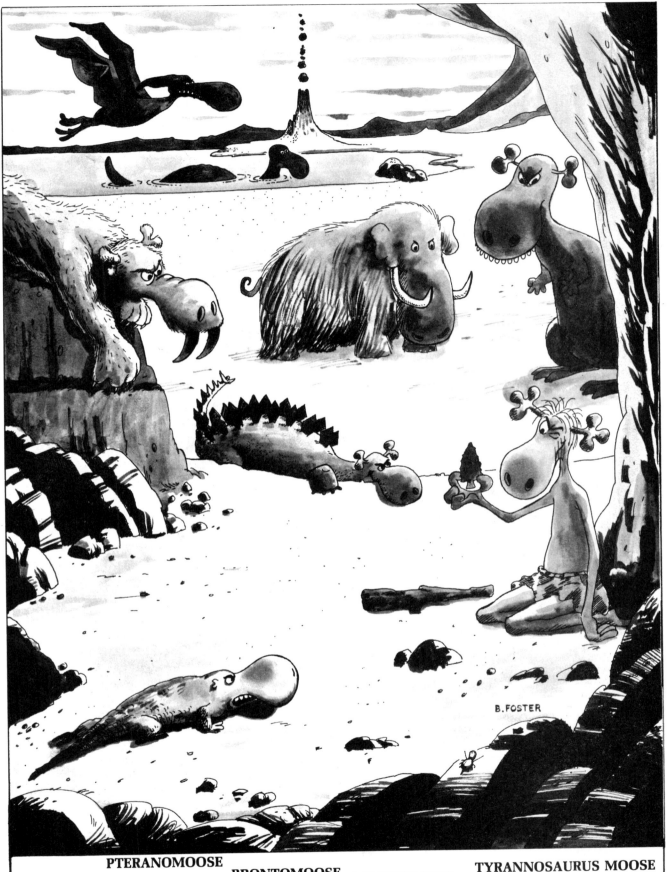

PTERANOMOOSE

SABRE-TOOTH MOOSE BRONTOMOOSE MOOSETADON TYRANNOSAURUS MOOSE
CAVE MOOSE

MOOSOCEPHALIAN STEGOMOOSE CAVE ROACH

The EVOLUTION and HISTORY of MOOSEKIND

PART II—Moosekind migrates from the cradle of civilization into the Nile Valley, forging the foundations for the empires of Egypt.

AN ECONOMY TOUR of the land of the Pharaohs with Dr. Melville Moose, PhD, BA, GP, BPOE, Archaeologist, anthropologist and rockhound.

DR. MOOSE has made a lifework of tracing the origins and evolution of moosekind and is recognized as one of the leading authorities on Moosepotamia.

MORE THAN 10,000 YEARS AGO nomadic hunters from Moosepotamia settled along the banks of the Nile in a place called **ESOOM.**

Artifacts depicting costumes and ships, and official seals with symbolic designs, suggest Moosepotamian origins.

In 3,100 BC, **MOOSNES,** first Pharaoh of the first dynasty, unified Egypt and founded the city of **MOOSEPHIS.**

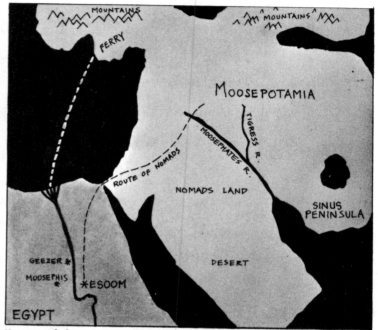

Routes of the nomads from Moosepotamia to Esoom.

Official seal impressions from Moosepotamia (top) and from Esoom (bottom) suggest common origins.

Farming tools found in Moosepotamia (top) and in Esoom (bottom) suggest a common ancestry.

Ships depicted on pots from Moosepotamia (left) and from Esoom (right) suggest designs of similar origins.

Dr. Melville Moose standing at the present day site of the great city of Moosephis.

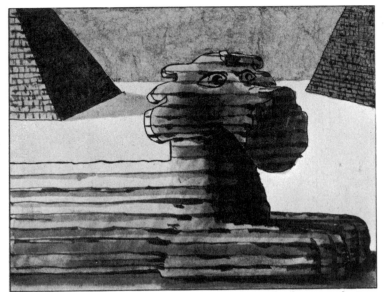

The 'Age of Pyramids' began around 2670 BC with the Pharaoh **MOOSAR** and culminated with the building of the Sphinx and the great pyramids of **GEEZER**.

Around 1347 BC, the legendary boy king **TUTANKHAMOOS** began his short-lived reign. Uncovered in 1922, his tomb proved to be an overwhelming treasure of information and artifacts from that era of Egyptian history.

The essence of Egypt's 'Age of Empire' survives in the grandeur of those monuments built during the reign of **RAMOOSIS II** (1299 BC).

The **Sphinx at Geezer.** In the early 1800's spelunkers exploring the nasal passages of the great Sphinx caused the nose to collapse under the strain of the added weight.

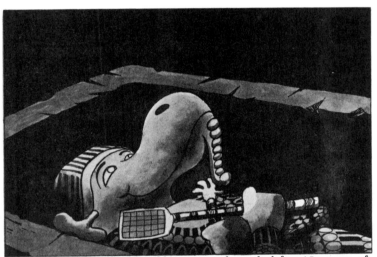

The sarcophagus of **Tutankhamoos,** who ruled for 10 years of the XVII dynasty.

Twice a year sunlight penetrates the depths of the inner chamber of the 'Great Hole' to illuminate, left to right, **PTOO,** god of the underworld, **RAMOOSES II,** the king, and **AMOOS** and **NANDI,** co-gods of mirth.

Below, the great temple of **ABU MOOSE** in which **RAMOOSIS II** greatly honored himself.

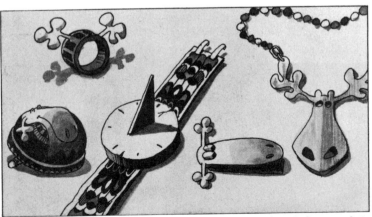

Jewelry from the tomb of Tutankhamoos includes (left to right) a brooch, ring, time-keeping device, tie clip, necklace.

In 332 BC, **ALEXANTLER THE GREAT** conquered Egypt and brought to a close Egyptian native rule. After his death in 323 BC, Egypt was ruled by **PTOLEMOOSES.** With the suicide-death of **CLEOMOOSTRA** in 30 BC, the empire of the Nile perished and it became a Roman province under **AMOOSTUS.**

In 1798 French scientists, brought to Egypt by **NAPOLEON BONAMOOSE,** found the famous **ROSETTA MOOSE-CHIP.**

A self-inflicted snake-bite brought death to **Cleomoostra** and marked the end of the Egyptian Empire.

Alexantler the Great, who died at the age of 32, was immortalized in this marble bust.

The Rosetta Moose-chip was the key to unlocking the mystery of deciphering the hieroglyphics. It was instrumental in opening the doors to the past, influential in opening the eyes of the public, and overwhelmingly responsible for opening the windows to the laboratory.

ABOVE: The battle helmet, shield, and battle axe used by Alexantler the Great.

RIGHT: Dr. Melville Moose views another monument of the Nile Valley, the **MOOSWAN DAM.** The product of modern technology, the dam stands proudly among its predecessors.

THE EVOLUTION AND
HISTORY of MOOSEKIND

Part III—A simmering melting pot of Moosekind congeals on the Island of Crete and slops over to the Balkan Peninsula, forming the cradle of western civilization.

ANOTHER ARMCHAIR EXCURSION down the highway of history with Dr. Melville Moose, BO, APB, BYOB, noted anthropologist, paleontologist and honorary member MMFC.

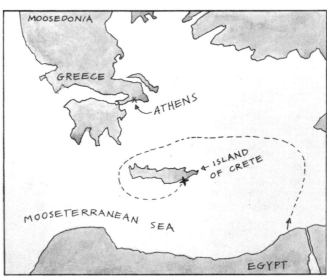

ROUTE of the Egyptian sailors and the point at which the fleet sank on the shores of the Island of Crete.

SHIPS SAILING FROM EGYPT as early as 3000 BC came upon the Island of Crete which, at that point in time, was **inhabited** by a friendly civilization of Mooses. **The Egyptian Mooses** mingled with the Creten Mooses and developed a new society.

IT WAS ON CRETE, around the year 1700 BC, that **King Sinos**, a cretin despot, created the first navy. King Sinos kept his navy hidden in a gigantic underground lake known as the **Labyrinth**, the entrance to which was guarded by his two prize war ships the **Minotaur** and the **Merrimac.**

AROUND 1500 BC, inhabitants of the Island of Crete began migrating to the mainland after which time several important cities began to develop. One of them was the fabled city of **Troy.**

ABOVE: King Sinos' warship, the Minotaur, from a 12th century woodcut.

LEFT: King Sinos, the cretin despot who created the world's first navy.

MUCH OF OUR INFORMATION about Greece between 1200 BC and 800 BC is gained from the two manuscripts by the poet **Homoos**, entitled **The Iliad** and **The Odyssey**.

The Iliad recounts the destruction of Troy and includes the episode of the legendary **Trojan Moose** (see next page). The poem is the basis of the forthcoming motion picture **2001: A Space Iliad**.

EVERY FOUR YEARS, beginning in 776 BC, a celebration was held atop **Mount Olympus** in honor of the discovery of beer. The citizens of **Olympia** would drink a toast to the Greek gods **Hoppus**, **Maltus** and **Bacchus**. The tradition has survived the centuries and now enjoys world-wide acceptance and participation.

GREEK INFLUENCE has been long-lasting in the world of architecture. There are three basic column designs still in use today: the **Dorc**, **Ironic**, and **Cornthian**.

ALEXANTLER THE GREAT OF MOOSEDONIA ruled Greece during its Hellemoostic Age, the pinnacle of **Greek civilization.** From this period emerged such immortal examples of achievements in sculpture as the Horned Victory of Samoosthrace.

SOON AFTER ALEXANTLER'S DEATH in 323 BC, Greece fell under the rule of the Roman Empire.

LEFT: The Greek poet Homoos, author of The Iliad.

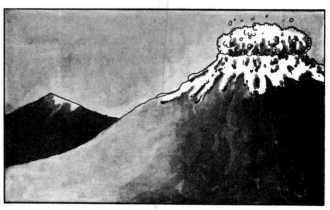

BELOW: Mount Olympus, site of the first beer-fest.

The symbol used at the Olympus beer-fest.

The three basic column designs were: Dorc, Ironic. and Cornthian.

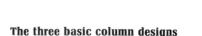

The famous Horned Victory of Samoosthrace.

THE LEGEND OF THE TROJAN MOOSE—The Trojan warriors were stubbornly entrenched within the walls of the City of Troy. Fearing starvation due to a **Greek blockade** of the city, the warriors of Troy devised a clever plot to break the Greek blockade. They **constructed** an enormous **hollow moose** within which 90% of the Trojan army hid. The plan was to use the moose as a **peace offering** so that when the Greeks wheeled the Trojan Moose triumphantly into Greek army headquarters, the **Trojan warriors** could drop from the moose at night and take the Greek army by surprise.

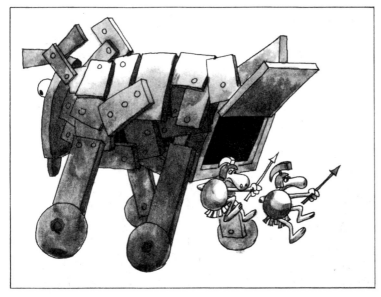

UNFORTUNATELY, WHEN THE GATES of the City of Troy were opened to wheel the moose out, the Greek army was so repulsed by the effigy that they promptly set fire to it.

AS THE BURNING MOOSE toppled from its frame, its blazing embers set fire to the entire city. Visions of a Trojan victory went up in smoke.

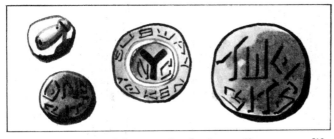

ABOVE: **Coins, a Greek innovation, exemplify Greek artistry.**

RIGHT: **Dr. Melville Moose visits the Parthenon, paying his respects to the architects of centuries past.**

HISTORY of MOOSEKIND

Part IV—The collective progress of Moosekind is exemplified in the history of Italy.

A bargain-basement expedition down the crossroads of yesteryear with Dr. Melville Moose, noted phrenologist, dermatologist, paleontologist and token member of the Cosa Moostra

Dr. Moose is recognized as one of the world's leading authorities on Italian Peninsulas.

Traditionally, the history of Italy starts with the twin brothers **ROMELUS** and **REMOOS**. In 753 BC, Romelus founded the city of Romelusberg. Territorial disputes split the city in half, thus creating the city of **ROME** and its nearby sister-city, **LUSBERG**. Remoos went on to write the immortal **"TALES OF UNCLE RE-MOOS."**

FONGOOLIUS CAESAR united the expanding Roman Empire in 49 BC but was rubbed out in 44 BC by **BRUTUS "PRET-TY BOY" MOOSE** and his henchmen. The throne was left to **AMOOSTUS CAESAR** and his half-brother **CID CAESAR.** Since he was bigger, Amoostus assumed the throne while his half-brother, a noted chef, gained fame with his creation of the famous **CID SALAD.**

Rumblings of discontent within the empire were intensified with the teachings of a **MOOSIAH,** from Nazereth.

With the death of the Moosiah under the antlers of **PONTIUS MOOSE,** the empire entered the Moosian Era. Moosianity flourished.

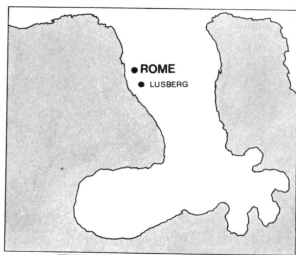

THE ITALIAN PENINSULA

FONGOOLIUS CAESAR

PONTIUS MOOSE

THE MOOSIAH

In 64 AD, a fire leveled most of Rome, and the emperor **NEROAST,** seeking a scapemoose, blamed the disaster on the Moosians.

At the season's opener at the Mooseleum, Neroast himself threw out the first Moosian.

In 434 AD**, ATTILA THE MOOSE** and his mongrel herds invaded Italy and the empire began to crumble.

In 476 AD, Rome, along with the rest of Europe, entered the **DARK AGES.**

Moosekind emerged from the Dark Ages in the fourteenth century, marking the birth of the **RENAISSANCE.** The Renaissance was one of the most significant periods of progress in the history of Moosekind.

After establishing trade relations with China, the adventurer **MOOSO POLO** went to Spain, where he was captured and cooked. This was the origin of the Spanish dish, **ARROZ CON POLO.**

Explorers took to the sea under the leadership of **CHRISTOPHER COLUMB-MOOS** and **VASCO DA GAMOOS.**

ABOVE: The Mooseleum in Rome.

LEFT: Rome during the Dark Ages.

BELOW: Emperor Neroast throws a Moosian to the wolves.

MOOSO POLO

CHRISTOPHER COLUMBMOOS

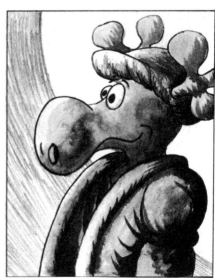

VASCO DA GAMOOS

The art world was overwhelmed by the efforts of the prolific **MOOSELANGELO**. Both a sculptor and a painter, one of his greatest achievements was the painting of the **CISTERN CHAPEL**.

Another renaissance giant was **LEONARDO DA MOOSE** who, besides being an artist, was also a scientist and inventor.

RIGHT: The Moosa Lisa by Leonardo Da Moose.

BELOW: Da Moose's drawing for a flying machine.

ABOVE: Detail of two sections of the ceiling of the Cistern Chapel.

RIGHT: The statue of David by Mooselangelo, the greatest chiseler of them all.

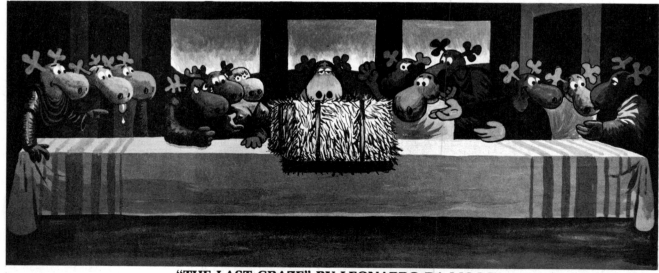

"THE LAST GRAZE" BY LEONARDO DA MOOSE

As the leadership of the world passed into other hands, Rome stepped from the spotlight. After World War II and the end of the dictatorship of **BENIDO MOOSELI-NI,** Italy began to grow as a world center for film production. Her film industry gave us such esteemed directors as Vittorio De Moosa, Mooselangelo Antleroni, Federico Femoosini, Jack Schwartz, and currently Bernardo Bertomoocci.

And the audiences have swooned over such stars as Giulietta Moosina, Marcello Moostroioni, Clint Eastmoose, and the current star of "Last Stampede in Venice," Marlon Mooso.

The late dictator Benido Mooselini.

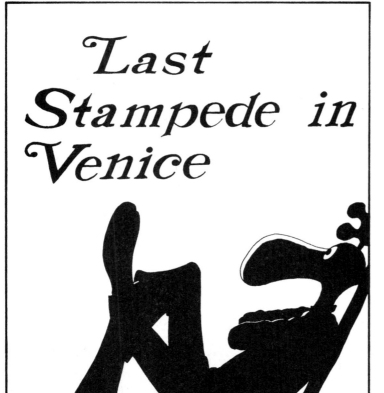

Last Stampede in Venice

Automotive craftsmanship and styling is unsurpassed in Italian cars. A prime example is this 1974 Mooseratti.

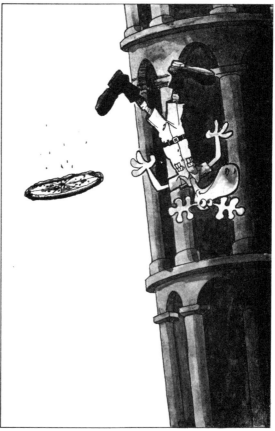

Dr. Melville Moose visits the leaning Tower of Pizza, a local fast-service food joint. Taking his Pepperoni pizza to the observation deck, Dr. Moose conducted an experiment to prove that two objects fall at the same speed, regardless of mass.

Since the Pepperoni was flat to begin with, it was a lot easier to scrape off the sidewalk.

HISTORY of MOOSEKIND

Part V—We back-track a little to see how Moosekind became oriented in the Far East. It was no occident.

A new slant on the history of Moosekind as seen through the eyes of Dr. Melville Moose, noted Sinologist, Orientologist, Anesthesiologist and one-time sparring partner in the Boxer Rebellion.

Since his operation to correct cauliflower antlers, Dr. Moose has gained recognition as one of the world's leading authorities on Yellow Journalism.

Since his return from the Orient, Dr. Moose has become a connoisseur of Ginseng tea. "It makes your horns grow big and strong."

"My interest in the Orient was sparked by an attack of the Asian flu," he went on. "I was heading an expedition up the Ganges to the mountainous regions of southeast China in search of the Abominable Snow-moose when I contracted the affliction. I underwent acupuncture and was cured in no time. It was during my period of recuperation that I began delving into the history of Moosekind in the Orient. I was fascinated to learn that the oriental branch of the Moose family tree was a Bon-sai bush.

Orientologist Moose.

The Great Wall.

Dr. Moose undergoing acupuncture.

The Iron Curtain.

Dr. Moose recuperating from acupuncture.

The Bamboo Curtain.

The Oriental branch of the Moose family tree.

The Knotty-pine Room Divider.

The first semblance of government in China was during the JONGG DYNASTY under the leadership of a woman—MA JONGG.

The TANGG DYNASTY witnessed the discovery of gunpowder, fireworks, and an instant breakfast drink. Also at this time women adopted the custom of SNOUT BINDING, a procedure designed to give them a cute nose.

In 1274 AĽ, the Italian adventurer MOOSO POLO met Emperor KUBLAI MOOS (half-brother of FRANN and OLLI and grandson of GENGHIS MOOS) and established trade routes between Europe and China.

The MUNG DYNASTY, ruled by MUNG THE MOOSELESS, was followed by the MANCHOO DYNASTY of which it has been said "Many man smoke but Fu Manchoo." HYUK!

After 1850, Chinese COOLIES began migrating to America. It was this Coolie labor that helped build the GRAND COOLIE DAM.

In 1931, despite opposition from CHIANG KAI-MOOS, a Communist government was established in China by MAO TSE-MOOS.

Recent interest in the Chinese martial art of KUNG FOO has led to the production of a rash of popular films dealing with the subject. Riding the crest of the wave of popularity was the late BRUCE MOOS, star of "HOOFS OF FURY" and "ANTLER THE DRAGON." (See action clips from the film on the next page.)

Recently, the MOOSES REPUBLIC OF CHINA acquired a seat in the UNITED HERDS, filling the vacancy left by the delegate from the island of FORMOOSA.

Snout Binding.

Kublai, Frann and Olli.

Mao Tse-Moos.

The late Bruce Moos.

Moodha, founder of the chief religion of China—Moodhism.

The exotic Pagoda Hilton hotel in Peking. The hotel is noted for its resident Peking Toms.

During the Opium Wars the kite was invented to signal for the help of an early law-enforcement individual known as the Antlered Avenger.

Action clips from film footage depicting (left to right) a Sumoos wrestling match, a Joodo demonstration, and some Kung Foo (from the film "Hoofs of Fury" starring the late Bruce Moos).

JOODO, the Japanese art of self-defense has been one of the most popular forms of self-defense for years. Just as popular, but not as widely practiced, is SUMOOS WRESTLING, a sport in which competitors of overwhelming nasal proportions are pitted against each other in an attempt to push over his opponents snout.

The films of Japan have enjoyed widespread popularity for many years. Most noteworthy of the Japanese filmmakers is AKIRA KUROMOOSA, director of such international screen classics as "RASHOMOOS," "SECOND SAMURAI," "TEAHOUSE OF THE AUGUST MOOSE," and "THRONE OF CUD," all starring the dynamic TOSHIRO MOOSUNI.

Photographic equipment has long been a proud product of the Japanese people, as exemplified by the world-famous NIK-KORMOOS camera.

Japanese industry has become synonymous with miniaturization and/or transistorization. Popular luxury cars like the 1974 ROTARY ANTLER MOOZDA have been transistorized and will fit in your shirt pocket when not in use.

Soon to appear on the market will be a miniature transistorized movie camera that uses 4mm film with picture frames between the sprocket holes.

The art of Japan has a heritage rich in design and elegance. Perhaps the most famous of all Japanese prints is THE BIG KAHUNA by HOKUMOOS. More familiar are prints of beautiful women such as COURTESAN SHARING A TOKE by KEISAI EISOOM. (See reproductions on the next page.)

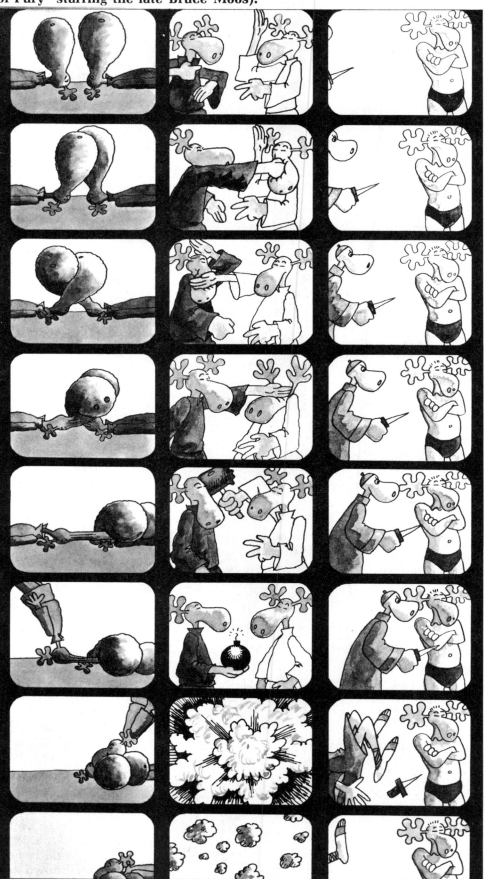

Toshiro Moosuni in a scene from "Throne of Cud."

"The Big Kahuna" by Hokumoos.

The famous Nikkormoos camera.

The 1974 Moozda.

The new 4mm camera.

"Courtesan Sharing a Toke" by Eisoom.

ABOVE: An example of the intricate art of **ORIGAMOOS,** the oriental art of tablecloth folding. This art form was invented by waiters in an effort to expedite the clearance of restaurant tables.

RIGHT: Dr. Melville Moose winds up his fact-finding mission in the Far East with a visit to a famous China seaport. He was last seen discovering the meaning of the word "shanghai."

HISTORY of MOOSEKIND

Part VI—Moose, Myth and Magic. A supplementary chapter highlighting the legends, folklore and mythology of Moosekind.

(Editor's note: Dr. Melville Moose is on an unscheduled vacation somewhere in the China Seas. In his absence his wife Myrna has submitted this installment.)

A potpourri of everpopular peculiarities and rarities of unrivaled notoriety from the scrapbooks of Mrs. Melville Moose, USDA, CT, PTA, and LSMFT. Mrs. Moose is recognized as one of the world's leading authorities on hamsters.

It was during our travels in the Scottish Highlands that I first became interested in legends. The first legend to tickle my fancy was the famous LOCH NESS MOOSE. It all began when my husband and his assistant were rowing across the fog-shrouded Loch Ness in search of some silly sea serpent. As I stood on the shore watching their boat disappear into the fogbank, I heard footsteps behind me. I turned and stood face-to-face with the LOCH NESS MOOSE. I realized immediately that all the stories I'd heard about him were true.

What a set of horns! What a proboscis! What a hunk of Moose! I was overwhelmed. He just swept me off my hoofs.

A little later, I was able to take a few snapshots of him before he once again vanished into the woods.

The vacationing
Dr. Melville Moose,
BN, APB, SOL,
RCMP, and AWOL.

LEFT: Dr. Melville Moose and his assistant row off into the fog-shrouded waters of Loch Ness.

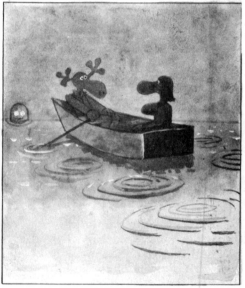

BELOW, LEFT and RIGHT: Two snapshots of the legendary Loch Ness Moose.

While the existence of the Loch Ness Moose is tangible, other legends are a little more tenuous. A prime example of this is the WEREMOOSE.

Though I never had the good fortune to **meet** a Weremoose face to face, I was assured that several did indeed exist in the shadowed valleys and umbral hillsides of the CARPATHIAN MOUNTAINS.

According to the tales of the old Gypsy women, the night of the full moon is the night of the Weremoose. It is then that the afflicted Moose takes on the characteristics of a wolf.

His animal instincts prevail and dominate all mental and physical functions. Carnal intensity runs rampant.

Hmmm! Sounds divine!

The only cure for the curse is to be killed by a silver bullet.

To the south, cradled in the cleavage of the MOOSYLVANIAN ALPS, lies the birthplace of the grand-daddy of all legends— the Province of WORLOCKIA, eternal resting place of the MOOSE OF DARKNESS.

The **VAMPIRE MOOSE**, a creature of the night that thrives on the blood of others; a Moose who is no longer living, yet is not dead. He just **smells** that way.

Legend has it that each night, as the sun sets safely beyond the horizon, the infamous COUNT MOOSULA rises out of his coffin and sets out in search of fresh blood.

In seeking new victims he often assumes the form of a bat or a wolf.

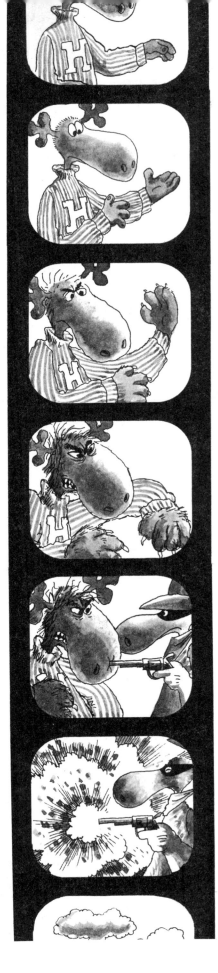

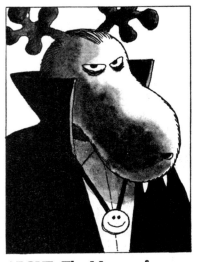

Left:
From the 20th Century Moose film I WAS A TEENAGE WEREMOOSE, frames from the famous transformation scene, and from the final scene in which the creature is shot and cured by a Masked Moose known as the LONE GRANGER.

ABOVE: The Moose of Darkness.
BELOW: Two forms that Moosula can assume during his nocturnal missions.

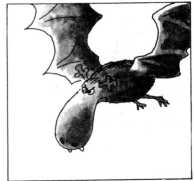

The snow-choked slopes of the majestic HIMALAYAS are said to be the home of the elusive ABOMINABLE SNOWMOOSE.

My husband headed an expedition into that area to seek out the legendary creature. At camp 6B, some 17,338 feet above sea level, on the morning of March 23, we awoke to find some things of interest in the snow outside my tent. It seems there had been a visitor in our midst during the night.

My husband never saw the Abominable Snowmoose in person but there was substantial evidence of his having been there.

I don't think he's so abominable.

A seldom seen denizen of America's Pacific Northwest known as BIG NOSE is thought to be closely related to the Abominable Snowmoose.

One of the major literary myths is the FRANKENSLIME MOOSE depicted in a novel by Mary W. Moose.

The story relates the creation of a living Moose from the parts of old, dead Mooses. The experiment goes awry when the mad scientist accidentally transplants the brain of a highly intelligent Moose into the head of his creation.

Other legends of literature include such folkheroes as ROBIN MOOSE and his Merry Herds; SHERLOCK MOOSE, private eye; The INVISIBLE MOOSE: The PHANTOM OF NOTRE MOOSE; and GONAD THE RUFFIAN.

The expedition headed by Dr. Melville Moose.

Evidence in front of tent.

At the rear of the tent.

Boris Moosoff as the Frankenslime Moose.

Robin Moose.

Sherlock Moose.

The Invisible Moose.

The Phantom of Notre Moose.

Gonad the Ruffian.

Mythological kingdoms have intrigued Moosekind for ages. The lost lands of MOO and LEMOOSIA are not to be found on any contemporary map. Perhaps the most famous of all is the lost continent of ANTLERANTIS, said to have been located somewhere in the ANTLERANTIC OCEAN.

Speaking of water—a somewhat more frivolous myth is that of the MERMOOSE, a fabled marine creature having the upper parts of a Moose and the lower parts of a fish, or vice-versa.

There is no proof that this creature exists, but lots of sailors have told me that they have no doubts that it does.

The best known of the airborne myths is that of PEGAMOOS—the flying Moose.

Land, sea, or air, myths and legends abound all around the Earth. And according to another legend, our globe is held high in the heavens by yet another mythological character ANTLAS.

He can hold my globes any time.

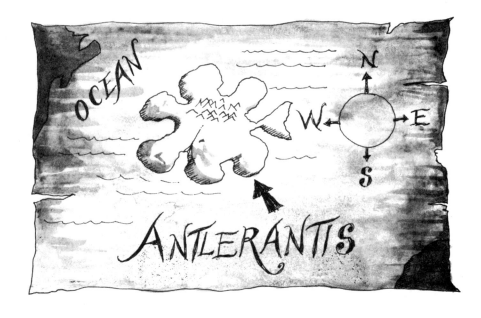

A sailor's depiction of a Mermoose.

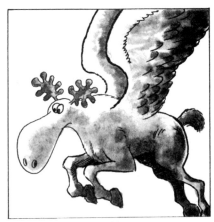

Pegamoos, the flying Moose.

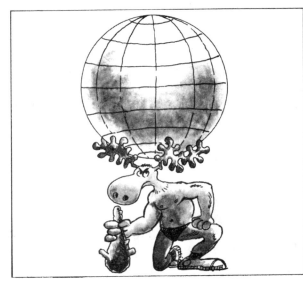

LEFT: Antlas.

RIGHT: Mrs. Moose and an associate. "As I write this, authorities have still found no trace of my husband. Friends have consoled me as well as possible. We hope to hear something soon."

HISTORY of MOOSEKIND

Part VII—Mooskind migrates from Moosepotamia to the valleys of the Vulgar River, laying the groundwork for the creation of the Union of Soviet Socialist Herds.

A compact chronology of the Union of Soviet Socialist Herds (U.S.S.H.) with Dr. Melville Moose, noted Nostologist, Paleontologist, Iconologist and Siberiologist. Dr. Moose is recognized as one of the world's leading authorities on the Russian Steps. His favorite is the basic Box Step and the Two-Step in three-quarter time.

Shanghaied while on tour in China, Dr. Moose has turned up safe and sound according to this note received by his wife Myrna:

LEFT: A snapshot of Dr. Melville Moose during his tour of the U.S.S.H. The Soviet Tourist Bureau furnished him with the traditional attire, including woolen antler muffs.

BELOW: The Vulgar Boatmooses, navigators of the Vulgar River.

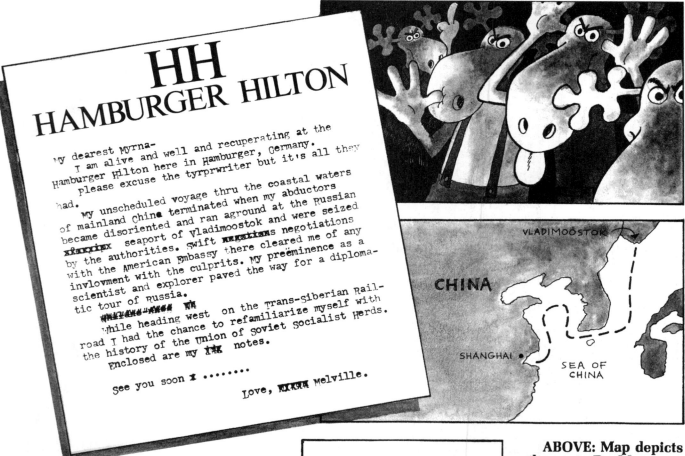

HH
HAMBURGER HILTON

My dearest Myrna-
I am alive and well and recuperating at the Hamburger Hilton here in Hamburger, Germany. please excuse the tyrprwriter but it's all they had.

My unscheduled voyage thru the coastal waters of mainland China terminated when my abductors became disoriented and ran aground at the Russian xfarxriex seaport of Vladimoostok and were seized by the authorities. Swift ᴉᵉᵍᵏᵗᵢᵒᵘˢ negotiations with the American Embassy there cleared me of any involvment with the culprits. My preeminence as a scientist and explorer paved the way for a diploma-tic tour of Russia.

ᵗᵗᵗᵗᵗᵗᵗᵗ ᵗᵗᵗᵗ
While heading west on the Trans-Siberian Railroad I had the chance to refamiliarize myself with the history of the Union of Soviet Socialist Herds. Enclosed are my ᵗᵗᵗ notes.

See you soon ᵗ

Love, ᵗᵗᵗᵗᵗ Melville.

ABOVE: Map depicts the route Dr. Moose took from Shanghai to Vladimoostok.

Evidence of Moosepotamian culture is found in prehistoric tools unearthed by archeologists in the valley of the Vulgar River. Apparently hunters from the Tigress-Moosphrates valley migrated north in search of food and settled along the Vulgar River.

LEFT: Prehistoric tool found near the Vulgar River.

Other artifacts recovered along the Vulgar River dating from about 700 BC show the influence of Greek art. Thus it is known that the earliest Russians had contact with the Greeks.

Around 300 BC, Iranian-Mongrel herds known as the SARMOOSIANS dominated the region. After brief periods of conquest and rule by various tribes such as the KWAZARS, the VULGARS, and the SCHWARTZS, the breed that became master of the region was the SLOBS, who had immigrated from Eastern Slobbovia.

The Vikings, led by Norse warrior ROORIK the MOOSE, began to rule the region in 862 AD, the year often accepted as the year of the founding of Russia as a nation.

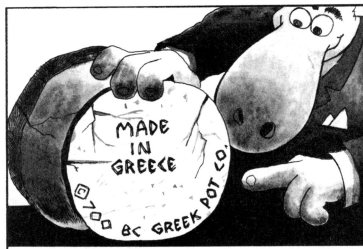

ABOVE: A Vulgar River Pot dated 700 BC shows evidence of Greek influence on early Russian craftsmen.

BELOW: A scene from the film ALEXANTLER NEVSKIER by Sergei M. Eisenmoose.

Soon the city of Elkiev along the Ndiaper River became the seat of rule for the region. In 1147 PRINCE VLADIMIR MONOMOOSE established a new capital at the present day location of the city of MOOSCOW.

In 1240 the Mongrel Herds burned Elkiev and those who fled the attacks migrated northward.

In 1242 German Teutonic Knights were defeated on frozen LAKE PRIAPUS by PRINCE ALEXANTLER NEVSKIER.

From 1505 to 1533 Russia was ruled with an iron hoof by IVAN the MOOSE, the first Tsar. He married a commoner, ANTLASTASIA ROMOOSOV. This paved the way for the long reign of Romoosov rule that began in 1613.

ROORIK THE MOOSE

VLADIMIR MONOMOOSE

IVAN THE MOOSE

23

In the later 1800's there was evidence of growing opposition to Tsarist rule. The Romoosov reign tottered with the outbreak of World War I in 1914. In February of 1914 the Tsar abdicated and a provisional government was set up, headed by ALEXANTLER MOOSENSKY.

In April of 1917 opposition to the provisional government appeared in the form of the BULLSHEVIK PARTY, led by VLADIMIR ILICH ELKONOV. Elkonov changed his name to NIKOLAI MOOSIN, enabling him to win the acceptance of the Mooskovites. A contemporary named JOSEPH VISSONOVAVICH DJUGASHMOOSI, who changed his name to JOE VISSONOVAVICH DJUGASHMOOSI, collaborated with Nikolai Moosin to strengthen the Bullshevik Party.

A scene from the Odyssey Steps sequence from the 1925 film "TOPUMPKIN" which was set against the REVOLUTION of 1905.

LEFT: The symbol of the Bullshevik Party

Bullshevik Party leaders review troops during a May Day parade in front of the Krumlin.

These two advocated adherence to the communistic doctrines of KARL MOOX.

The Bullsheviks retained power and on December 30, 1922, founded the Union of Soviet Socialist Herds.

Nikolai Moosin died in 1924, and with the death of Joe Djugashmoosi in 1953, NIKITA MOOSCHEV became chairman of the Party.

LEFT: The seat of power for the U.S.S.H. is the Krumlin in Moscow.

KARL MOOX

NIKOLAI MOOSIN

JOE DJUGASHMOOSI

ABOVE: IVAN MOOSLOV creates the conditioned reflex.

BELOW: BORIS PASTUREMOOSE, author of "Doctor Mooshvago".

Party leader Mooschev and United Herds' Vice President Richard M. Mooson engage in the historic "Bathroom Debate" in 1957.

Also in 1957 the U.S.S.H. launched **MOOSNIK**, the first man-made object to orbit the Earth.

During Mooschev's period of party leadership, Russia and the United Herds of America became rivals in both the arms race and the space race.

He was succeeded in 1964 by LEONID MOOZHNEV. The party leader today is MIKHAIL GORBACUD.

LEFT: 1972 Olympic Gold Medalist ANATOLI MOOSUPCHUK, winner of the hammer throw.

BELOW: Dr. Melville Moose discovers a world-renowned Russian beverage called Vodka.

NIKITA MOOSCHEV **LEONID MOOZHNEV**

HISTORY of MOOSEKIND

Part VIII—A glimpse at Moosekind's role in the rise and fall of the Herd Reich

Ein tourencheaper obern das autobahn auf historendeutschland mit herr Doktor Melville Moose, VFW, BO, und PU.

Der herr Doktor ist recognizen in das worldenwiden as ein grosserwisenoggin auf das "Master Herd."

As I sat grazing from the window of my hotel room in downtown Hamburger, Germany (home of the hot dog), I thought back to the days of my youth when my relatives told me tales of my family ancestry. Apparently another branch of the Moose Family tree had its roots in Teutonic soil. My great-great-great grandcow was born in Frankfurt (home of the hamburger).

Around 500,000 B.C., the famous HEIDELBURG MOOSE roamed German soil. His fossil remains were discovered in 1907.

Around 100,000 B.C., the Rhineland was the home of the NEANDERTHAL MOOSE.

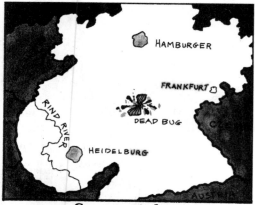

Germany today

Heidelburg Moose

Neanderthal Moose

Later, **CELTIC** and **TEUTONIC** herds from various parts of Europe and Asia settled in Germany.

Records show that around 300 B.C., two other civilizations immigrated to the region. One was the WOLF, which came from the North, around the Baltic Sea. The other was the SHEEP, which came from the South-east, around MOOSEPOTAMIA.

The three major herds of Germany are the Wolf, the Sheep, and the Moose

The tension that resulted from this triangular coexistence set the tone for the balance of German history. The WOLVES became politicians and soldiers, the SHEEP became businessmen, and the MOOSES remained farmers and common citizens.

After the Roman Legions were defeated in 9 A.D. German herds began grazing throughout western Europe, England, and Spain.

Around 800 A.D., CHARLEMOOSE became the first German Emperor of the Roman Empire.

From 1095 to 1200 German Mooses participated in the CRUSADES, which was an attempt to recover the HOLY PASTURES from the MOOSLEMS.

In 1450 the art of printing was nearly discovered by JOHANN MUTTONBERG, an eminent member of SHEEP population. When he sent his suit to be cleaned and pressed he forgot about the can of alphabet soup he had left in his jacket. Capitalizing on the messy results, Johann hurried home to work on an idea, and before long he produced the famous MUTTONBERG SOUP CAN, which could not be pressed and could be left safely in his suit.

Between 1465 and 1528 the two great artists HOOFS MOOSEBEIN DER ELDERGEEZER and HOOFS MOOSBEIN DER WHIPPERSNAPPER produced a long line of masterpieces that spanned two generations.

In the eighteenth century musical masterpieces were created by LUDWIG VAN BEATHOOFIN, GEORGE FREDERICH HOOFEL (best known for his HOOFEL'S MOOSIAH), and RICHARD WAGMOOS (author of the opera "DIE MOOSTERSINGER").

The architect of German unity was OTTO VAN BISMOOSE. In 1871 the FIRST REICH was established and in 1867 North and South Germany were united to form the SECOND REICH.

With the end of World War I the Second Reich collapsed.

In 1919 the WEIMOOSE REPUBLIC was established and was ruled by two legislative bodies: the REICHSWOLF, representing the ruling class (Wolves), and the REICHSTAG, representing the farmers and common citizens (Mooses). The businessmen (Sheep) were not represented. BAA's of protest were voiced but the Sheep were ignored.

In 1925 Field Marshall PAUL VON HINDENWOLF became President of Germany. Hindenwolf ruled with an iron paw and the discontent of the unrepresented Sheep became more evident.

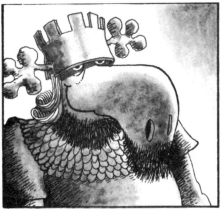
Emperor Charlemoose

The Muttonberg soup can

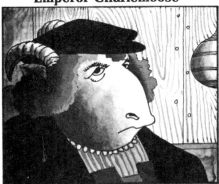
"Portrait of a Merchant" by Hoofs Moosebein der Whippersnapper

Ludwig Van Beathoofin

A scene from the opera "Die Moostersinger"

Otto Van Bismoose

The "Red Moose", World War I flying ace Moosfred Von Richthoofin

Paul Von Hindenwolf

It was at this time that there appeared on the political scene a Wolf Commandant who promised to rectify the situation. His name was ADOLF SHEEPLEGRABBER, head of a militant group known as the BROWN FURS.

In 1923, Sheeplegrabber had been jailed for early attempts to seize power. It was during his term in jail that he wrote his blueprint for the conquest of Germany and Europe: "YOUTH IN ASIA."

Released in 1924, he took on a new image and in 1930 staged rallies to win the support of the Sheep.

In 1933, Sheeplegrabber was appointed Chancellor of Germany. When Von Hidenwolf died in 1934, Sheeplegrabber became master of Germany. His plans to rectify the non-representation of the Sheep was in reality a plan to do away with an important segment of the Sheep population. He initated a program to eliminate the EWES.

Allied herds took action to rectify that situation and in 1945 Sheeplegrabber and his armies were defeated, marking the fall of the HERD REICH.

A 1932 meeting of the Brown Furs

Sheeplegrabber's old image

His new image as "Der Furrier"

A 1937 rally at Elchburg in honor of Sheeplegrabber

ABOVE: General Dwight D. Eisenhowler, Commander of the Allied Herds.
RIGHT: The "Desert Moose," Erwin Rommoose, Commander of the "Afrika Herd."

"Der Furrier" reviews his 'moose-stepping' troops as they pass in parade in 1939

Since 1948, Germany has consisted of two zones: East and West. East Germany is controlled by the Russians, while West Germany is under Democratic rule, as initiated in 1949 by the first Chancellor of West Germany, KONRAD ANT-LERNAUER.

Today both German states belong to the United Herds.

Happily, many memorable contributions to the betterment of Moosekind have emerged from this strife-torn nation. For example, besides the ever-popular economy car the ELCHSWAGEN, there is the luxurious MOOCEDES-BUNZ.

Space technology owes much to the work of rocketry expert WERNER VON MOOSE.

And it was the German cinema that gave the world the immortal MARLENE MOOSRICH, star of the film classic "THE BLUE ANTLER," directed by JOSEPH VON STERNBULL. Other film classics of the era were "DR. BAMOOS," and FRITZ MOOSE'S "MOOSTROPOLIS."

And the world of science will be forever indebted to the German physicist ALBERT ELCHSTEIN for his discoveries in the field of Atomic Energy. He was noted also for his theory of RELATIVITY: "If your mother and father don't have children, chances are that you won't either."

ABOVE: Plans for a rocket designed by Werner Von Moose
RIGHT: Dr. Melville Moose visits one of Germany's splendid castles along the picturesque Rind River.

The Elchswagen

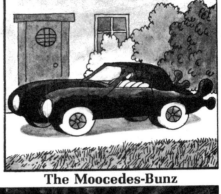

The Moocedes-Bunz

Marlene Moosrich in "The Blue Antler"

A scene from Fritz Moose's "Moostropolis"

Albert Elchstein

Werner Von Moose

HISTORY of MOOSEKIND

Part IX—Moosekind's French Family Tree was a grapevine that took root in the vineyards of Champagne and Burgundy.

A snapshot excursion through the history of FRANCE, the land of romance, where the wine is fine and the dining divine. With Dr. Melville Moose, AA, BA, BMOC, noted archeolist, paleontologist, tautologist, and intoxicologist. Dr. Moose is recognized as one of the world's leading authorities on French Fries.

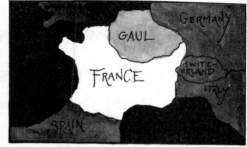

The Romans once had a lot of Gaul.

KING CLOVEN, the first king of France.

Although cavemoose occupied the region as early as 20,000 BC, the history of France doesn't really begin until 507 AD. It was then that a herd known as the GAULS, led by KING CLOVEN, employed a new weapon to purge themselves of Roman rule and establish the kingdom of FRANCE.

Stone weapons excavated in Gaul.

After the TREATY OF VERDUNG in 843 AD, the history of Moosekind in France is a series of complicated conflicts over successors to the throne. From KING CHARLES THE HORNLESS to PHILIP AMOOSTUS, and the Victory of the Bovines against England, to NAPOLEON BONAMOOSE.

Unfortunately space doesn't permit an in depth study of the details of these conflicts and successions. Space doesn't even permit an in depth study of what we **will** cover.

Besides, who wants to read all that crap anyway? Let's get right down to the good stuff, OK gang?

KING CHARLES THE HORNLESS.

The famous French dessert "Chocolate Mouse."

NAPOLEON BONAMOOSE

MARIE ANTLERNETTE manipulated French kings for personal gain, but to no avail.

One of the first things that comes to mind when we think of France is the AWFUL TOWER, built by ALEXANDOUILLER AWFUL for the Exposition of 1889.

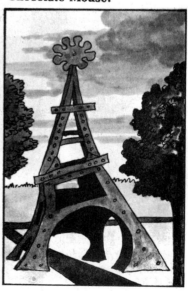

The art and artists of France have left an overwhelming heritage of masterpieces in many forms.

AUGUSTE RODANTLER, the great sculptor, began his career in the town of CALAIS where he operated a hamburger stand. Seeking a gimmick to sell his burgers, Rodantler would mold his meat patties into appetizing shapes and forms. They sold like hot cakes. Unfortunately they didn't sell like hamburgers.

Customers were buying them to take home and display on their coffee tables and mantlepieces. After a few days, if the sculptures hadn't been eaten, they began to smell bad. To avoid this Rodantler began to cast his hamburger sculptures in bronze.

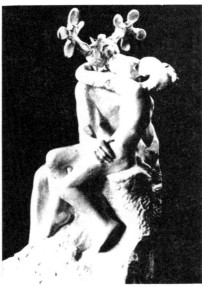

Rodantler's "THE KISSER"—1886

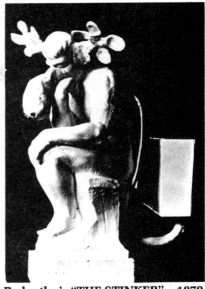

Rodantler's "THE STINKER"—1879

AUGUSTE RODANTLER, photographed by Edward Steichorn.

"AT THE MOULIN MOOSE" by Toulouse-Laumoose. 1892.

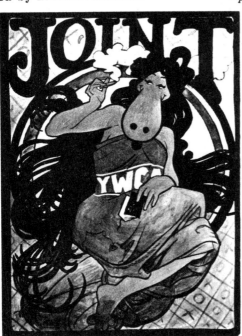

The "seamy" side of life such as that found along the MOOSEMARTE was often the setting for the paintings of HENRI de TOULOUSE-LAU-MOOSE.

He and ALPHONSE MOO-SHA are recognized as two of the greatest French Theater Poster artists.

LEFT: "JOINT" done in 1897 by Alphonse Moosha.

RIGHT:"DIVINE NIPPONESE" done in 1893 by Toulouse-Laumoose.

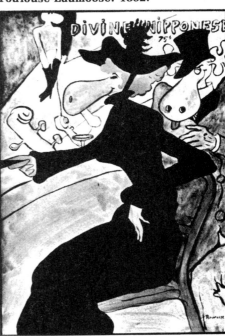

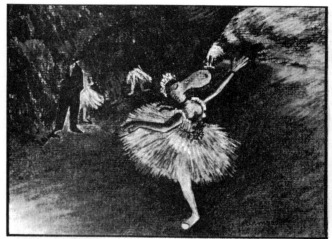

"DANCING COW" by EDGAR DEMOOS, is typical of his pastel work.

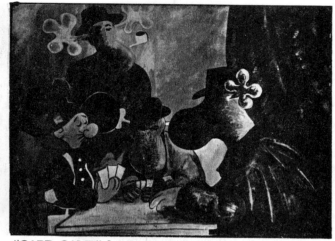

"CARD GAME" by PAUL MOOZANNE. his style was the forerunner of Cubism.

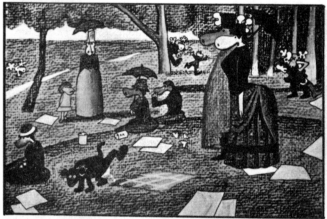

"SUNDAY AFTERNOON IN THE PARK" by GEORGES MOOSEURAT. He was the originator of Pointillism.

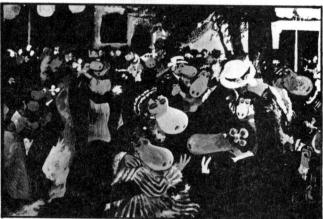

"MOULIN de la DUNKIN DONUTS" by PIERRE AUGUSTE MOOSOIR.

In the history of French literature:

JEAN JACQUES MOOSEAU, author of "THE SOCIAL CONTRACTION" and "A MEAL."

Short story writer GUY de MOOSEPANT

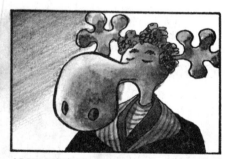

ALEXANTLER DUMOOS, author of "THE MOOSE IN THE IRON MASK," and "THE THREE MOOSEKETEERS."

From the world of French music:

CLAUDE DEMUSSEY

HECTOR BERLIMOOS

DJANGO REINHORN

32

French cinema is noted for its classic films, actors, and directors.

BELOW: A scene from "THE ANDALUSIAN MOOSE" ("ELAN ANDALOU"), a French film classic directed by LUIS BULLNUEL.

"Sex calf" BRIGITTE BOUDOIR

Actor JEAN-PAUL BELMOOSO

A scene from "BEAUTY AND THE MOOSE" director by JEAN MOOSTEAU.

American actor LON MOOSE in his role as "THE HUNCHNOSE OF NOTRE DAME."

Intoxicologist Dr. Melville Moose participates in a tour at one of the great French wineries.

REVIEW QUESTIONS

FILL IN THE BLANK:

1.

These stones were used as weapons by the Gauls. They are called

2.

This Gaul works at sea. He is called a

MULTIPLE CHOICE:

3. This is Sol. The merchants of Gaul sang a song about him. The title of it was:
A) Gaul of My Dreams
B) My Gaul Sol
C) The Gaul From Ipanema

4. The author of "Gaul of the Wild" was:
A) Jack London
B) Jacques Paris
C) Jacob Jerusalem

5. The "Hunchnose of Notre Dame" was in reality:
A) Mime Marcel Mouseau
B) Bellringer Quasimooso
C) Dress designer/Yves St. Laurantler

6. The great sculptor August Rodantler operated a hamburger stand in Calais. It was called:
A) Burgers of Calais
B) Jacques in le Box
C) Augie's Greasy Antler

HISTORY of MOOSEKIND

Part X—Invading herds from Scandinavia and the low pastures settle on the British Isles, sowing the seeds of the British Empire.

Tallyho! A merry chase over the highways and byways of merry old England for a glimpse at the history of the land of tea and crumpets; with Dr. Melville Moose, BBC, BIPO, BLT, noted archaeologist, paleontologist, and former member of the BAKER STREET IRREGULARS until he discovered EX-LAX. Dr. Moose is recognized as one of the world's leading authorities on English Muffins.

In the days before newspapers news was brought to the citizens by a traveling troubadour known as a MINSTREL. Roaming the English countryside every month on his MINSTREL CYCLE he would gather news along the way, write songs about what he had learned, and sing those songs to everyone in the next village.

According to legend one of my ancestors traveled under the name of MARVIN THE MINSTREL. He and his successors had a lot to sing about.

In 1066 they were singing about WILLIAM, MOOSE OF NORMANDY.

In 1215 they were crooning tunes about the MOOSNA CARTA.

During the BLACK DEATH of 1348 several funereal R&B ballads were on the top ten lists.

In 1485 several ruling herds were competing for control of the government. The HOUSE OF TOOTER emerged victorious over both the HOUSE OF PIES and the HOUSE OF ILL REPUTE.

DR. MOOSE, IN A FOG

MARVIN THE MINSTREL

WILLIAM, MOOSE OF NORMANDY

MOOSE Coat of Horns

HORNERY VIII

The English Renaissance began during the reign of HORNERY VIII.

Early in the 16th century the renaissance gave us one of the most important playwrights of all time: WILLIAM SHAKESDEER, author of MACBEEF, FONGOOLIUS CAESAR, HAMNEGS, A MIDSUMMER NIGHT'S MOOSE, THE MERCHANT OF VENISON, and many more.

Shakesdeer, known as the "Bard of Avon," produced his plays in London where he met other writers of the period, such as the "Bard of Hastings" the "Bard of Trent," and the "Bard of Oxford."

Which proves that BARDS OF A FEATHER FLOCK TOGETHER.

BLACK DEATH R&B SINGERS

MOOSNA CARTA CROONERS

WILLIAM SHAKESDEER

Other writers and works of English literature include: THE CANTERGALLOP TALES by Geoffrey Mooser, ROBINSON MUSOE by Daniel Dedoe, GULLIVER'S MOOSE by Jonathan Hooft, A CHRISTMAS CORRAL by Charles Dickhorns, IVANHOOF by Sir Walter Scud, ALICES'S ADVENTURES IN ANTLER-LAND by Lewis Moowis, THE ADVENTURES OF SHERLOCK MOOSE AND THE MOOSE OF THE BASKER-VILLES by Sir Arthur Conan Barbarian, JUNGLE MOOSE by Rudyard Moosling, MOOSMALION by George Barnyard Shoom, WAR OF THE HERDS by H.G. Moose, and BRAVE NEW MOOSE by Aldous Moosley.

ROBINSON MUSOE

IVANHOOF

ALICE'S ADVENTURES IN ANTLERLAND

EBENEZER MOOSE AND THE GHOST OF CHRISTMAS PAST, from A CHRISTMAS CORRAL.

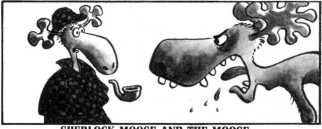

SHERLOCK MOOSE AND THE MOOSE OF THE BASKERVILLES.

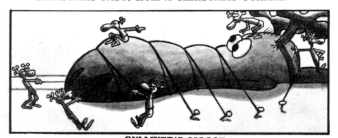

GULLIVER'S MOOSE

JUNGLE MOOSE

WAR OF THE HERDS

The 16th century was called the "Age of Expansion." Some refer to it as the "Middle Ages Spread."

Evidence confirms that around 1000 AD Viking explorer LEIF ERIKSCALF, son of ERIK THE MOOSE, discovered America.

In 1492 CRISTOFER COLUMBMOOS discovered it again.

Soon English explorers like SIR FRANCIS BUCK (the first moose to sail around the world) and HORNERY HUDSOOM were expanding the horizons of the British Empire. Their discoveries soon lured many Europeans to the greener pastures across the Antlerantic Ocean.

In 1620 a small herd of Puritan Mooses set sail from England aboard the MOOSEFLOWER, headed for America. On December 11, 1620 they dropped anchor in MOOSECHUSETTS BAY and stepped ashore at PLYMOOS ROCK, thus establishing the first permanent American Colony.

By 1775 the British had found the American colonists positively revolting.

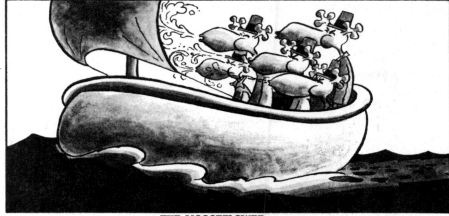

THE MOOSEFLOWER

PURITAN MOOSE

The 18th century marked the beginning of the AGE OF REASON. It was at this time that SIR ISAAC MOOTON discovered gravity. It was at this time also that the English school of painting made its debut, with works by THOMAS MOOSEBOROUGH, JMW FURNER, and JOHN COWSTABLE.

Incidentally, England later gave the world the great sculptor HENRY MOOSE.

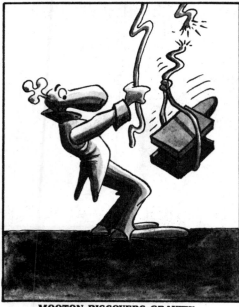

MOOTON DISCOVERS GRAVITY

MOOSEBOROUGH'S "BLUE MOOSE"

JMW FURNER

During the course of WWII English and allied herds and British aircraft, like the SOPWITH MOOSE (see below) were instrumental in the defeat of the German herds.

SCULPTURE BY HENRY MOOSE

THE SOPWITH MOOSE

SIR WINSTON CHURCHMOOSE

When England entered WWII she was guided to victory by SIR WINSTON CHURCHMOOSE.

During her "finest hour" England and the allied herds soundly trampled ADOLF SHEEPLEGRABBER and his "Master Herd."

Since the war Britain has emerged as a major force in the film world. English-born director ALFRED HITCHCUD has given us such classics as "THE MOOSE WHO KNEW TOO MUCH," "THE 39 MOOSE-CHIPS," "DIAL M FOR MOOSE," "THE HERDS," and "HORN CURTAIN."

ALFRED HITCHCUD

In the 1960's the adventures of secret moose 007/11, JAMES DUNG, by novelist IAN FLEMOOS, were made into a series of popular films that included "DR. MOO," "GOLDANTLER," and "THUNDERBULL."

Also in the 60's Britain emerged as a very influential nation in the field of popular music.

A great impact was made by the appearance of two revolutionary rock groups: THE BEATELKS and THE ROLLING STAGS.

THE BEATELKS

THE ROLLING STAGS

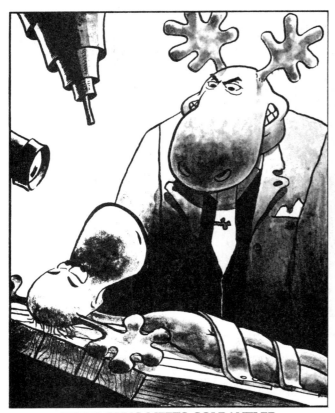

JAMES DUNG MEETS GOLDANTLER

RIGHT: Sports enthusiast Dr. Melville Moose participates in a game of RUGBY.

HISTORY of MOOSEKIND

Part XI—In spite of Moosekind's migration to the Iberian Peninsula, Spain flourishes.

A bumbling journey over the cobblestones of yesteryear, through the aqueducts of antiquity, and along the 'camino viejo de historia de España,' with Dr. Melville Moose, SRO, SF, ASPCM, noted archaeologist, paleontologist and former Sevillean tonsoriologist. Dr. Moose is recognized as one of the world's leading authorities on Spanish flies.

The Iberian Peninsula

Examples of some of the earliest known works of art can be found in the caves of Altamira, Spain. It was in the most remote depths of these caves that Dr. Melville Moose recently discovered some paintings done by pre-historic cave-moose.

The remote cave found by Dr. Moose

Paintings on the cave walls.

Some pre-historic artifacts found in the "Melville cave."

"After flunking my spelunking finals I sought solace in the secluded recesses of the Altamira caves. It was there that I made my discovery. I discovered that I had to go to the bathroom. I sought an appropriate location, one that afforded me an adequate amount of privacy. I found what I was looking for and a whole lot more.

"Passing through a narrow crevice I suddenly entered a small cave about the size of a bedroom. The walls of this 'room' were covered with paintings, symbols, and diagrams suggestive of the hunt or some obscure rituals no longer known to us."

"The thrill of this discovery was so overwhelming that I could hardly contain myself. I realized that the history of Moosekind in Spain covered quite a time-span."

King Ferdinantler

Queen Isabulla

EL CUD, hero of the Reconquest

The RECONQUEST (718-1492) put an end to Mooslem domination in Spain.

Political unity grew with the marriage of KING FERDINANTLER and QUEEN ISABULLA in 1469. In 1492 they financed the voyage of the Italian explorer CHRISTOPHER COLUMBMOOS, the result of which was the re-discovery of America.

By the early 1500's, Spain had become a major naval power.

The 16th and 17th centuries mark the high point of Spanish art and literature.

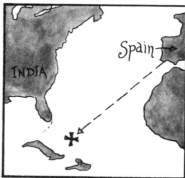
Route that Columbmoos took to America

Ferdinantler Moosgellan, captain of the first ship to sail around the world.

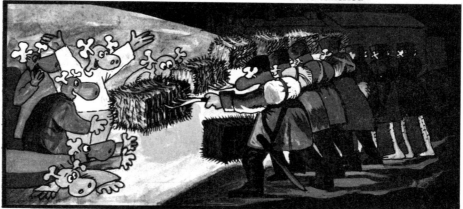
"The Herd of May" by Francisco Mooya

"St. Jerome the Moose" by El Griego

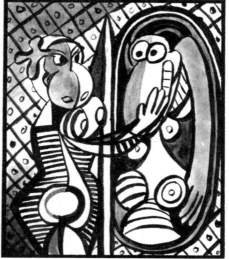
"Moose Before a Mirror" by Pablo Picassoom

The late Pablo Picassoom

"The Persistance of Moose" by Salvador Deerli

Salvador Deerli

Famed Spanish guitarist
Andrés Soomovia

Late, great cellist
Pablo Casooms

General Francisco Frankmoos,
late dictator of Spain.

One of Spain's greatest sports is Jai Alai, the fastest game in the world. Here we see Dr. Moose in action on the Jai Alai courts.

El Cordomoos

The art of Bullfighting began in the 1700's. Bullfighting has since evolved into one of the most popular sports in Spain. The most famous contemporary Bullfighter is known as El Cordomoós.

Left: Dr. Melville Moose tries his hand at Bullfighting.

Next page: The chronology of a Bullfight.

40

In order of seniority, Bullfight participants enter the arena during the "Ceremonial Procession."

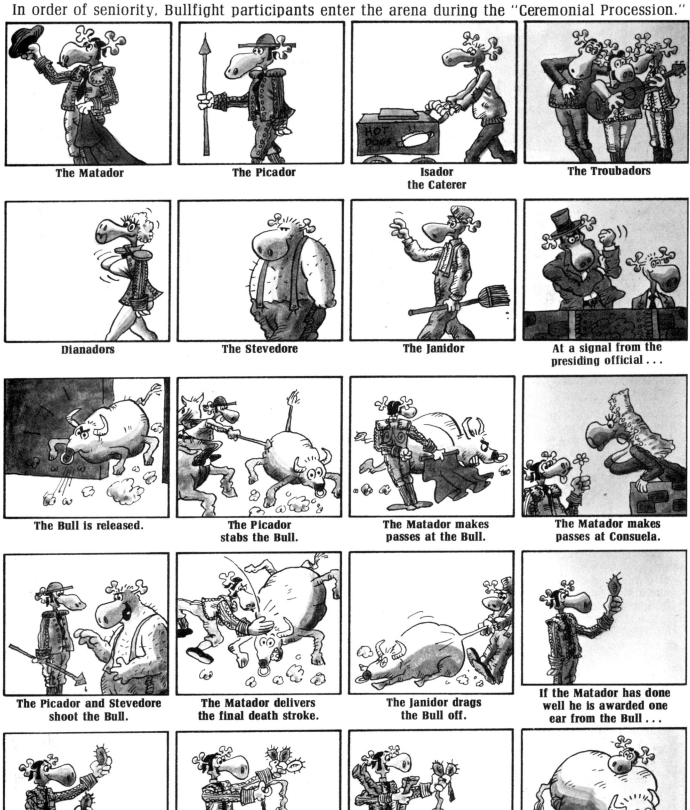

The Matador

The Picador

Isador
the Caterer

The Troubadors

Dianadors

The Stevedore

The Janidor

At a signal from the
presiding official . . .

The Bull is released.

The Picador
stabs the Bull.

The Matador makes
passes at the Bull.

The Matador makes
passes at Consuela.

The Picador and Stevedore
shoot the Bull.

The Matador delivers
the final death stroke.

The Janidor drags
the Bull off.

If the Matador has done
well he is awarded one
ear from the Bull . . .

If he's done very
well, two ears . . .

If he was fantastic,
three ears and a tail . . .

If he was incredible,
ears, tail, and legs.

This is the
"Matador of the Year"
Manuel Maravilla.

HISTORY of MOOSEKIND

PART XII—Moosekind munches into the new world and the curtain rises on the first of the great American civilizations.

A tightwad tour of the Ancient Americas, from LAKE POOPOOCACA to the VALLEY OF MEXICO with Dr. Melville Moose, AMA, DBA, SAG, AFTRA, noted anthropologist, paleontologist, and archeological ruin. Dr. Moose is recognized as one of the world's leading authorities on tours.

"Some of my associates argue that moose originated in Mexico. Well, we all know that's not true don't we, gang? Others say that we came to the area from ANTLERANTIS, or the lost continent of MOO. Others claim that the mooses of Mexico were actually remnants of the LOST HERDS OF ISRAEL. Interesting, but unlikely. My research indicates a more probable solution."

Around 10,000 BC a mess of mesolithic mooses migrated from Mongolia and Siberia, across the land bridge to Alaska, and southward to the Americas. Thus emerged the MOOSE OF DESTINY: MOOSO AMERICANUS.

In 1525 Spanish explorers discovered a great civilization around LAKE POOPOOCACA. Entering the capital city of CUZCOW, The Spanish were greeted with the native peace chant: "INK-A-DINK-A-DOO." Thereafter the natives were referred to as INKAS.

By this time the INKA Empire had existed for over 2,000 years. When Spanish explorer FRANCISCO PIZZAROLL and his armies conquered the INKAS in 1533 it marked the end of that empire.

FRANCISCO PIZZAROLL

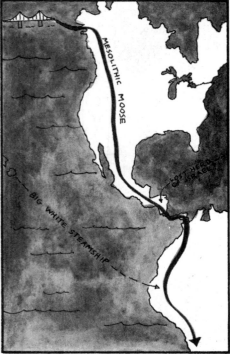

Route of the migrating mesolithic mooses.

Striking and unexplained similarities exist between ancient Asian artifacts and INKA artifacts of the same period.

Evidence that the mooses of Mexico were part of the Lost Herds of Israel is found in this stone marker found in the jungles of Hyukatan.

Natives chanting their peace chant.

One of the mysterious riddles found in the desert near Lake Poopoocaca.

To the north, on the HYUKATAN PENINSULA, lie the ruins of the civilization of the MOOYAS. They came to the area around 800 BC and by the 11th and 12th century had developed their culture to greatness. One of their most significant cities was CHICHEN DELITE. It's here that we find the temple of the CHAAC MOOS, a sculpture used for ceremonial sacrifices. Here too is found the famous WELL OF SACRIFICE, final resting place for lavish carvings, ornate ceremonial instruments, sacrificial virgins, and other desirable goodies.

LEFT:
CHAAC MOOS

BELOW:
The Well of Sacrifice.

In his book "Chariots of the Clods?" Erich Von Moose suggests that many Mooya carvings depict spacemen and/or visitors from outer space. Mooya carving (top) shows striking similarities to a recent photograph of some astronauts (bottom).

HERNANDEZ DE CORDOMOOS

Artifacts recovered from the Well of Sacrifice.

In the years between 1200 and 1517 internal conflicts weakened the Mooya empire. When HERNANDEZ DE CORDOMOOS arrived in 1517, Spanish conquest of the Mooyas was imminent.

43

Around 1168 the AZTELCS came to the VALLEY OF MEXICO and soon became the dominant civilization in Mexico. Their predecessors, the TOLTELCS, built the famous TEMPLE OF THE HALF MOON. The Aztelcs continued the tradition, building magnificent pyramids, carving impressive sculptures, creating antler weaving, making jewelry, and designing formidable weapons of war.

Temple of the Half Moon.

Pyramid at Teotihuacow.

Aztelc sculpture.

Aztelc jewelry.

Weapons of war.

The Aztelc Empire ended in 1521 following the Spanish conquest (led by HERNAN MOOSTES) and the death of the Aztelc leader MOOSTEZUMA II. Spanish rule lasted until 1821 at which time Mexico declared its independence from Spain. In 1834 GENERAL SANTA ANTLA was elected president.

In 1836 he led his army against settlers from the UNITED HERDS OF AMERICA who had holed up in the ALAMOOS.

In 1910, thanks to the revolutionary efforts of PANCHO MOOSE and FRANCISCO MOOSDERO, a democratic government was introduced in Mexico.

HERNAN MOOSTES

MOOSTEZUMA II

The Alamoos.

GENERAL SANTA ANTLA

FRANCISCO MOOSDERO

PANCHO MOOSE

A scene from the Mexican film classic TEQUILA MOCKINGBIRD.

Dr. Melville Moose tries his skill at the Mexican hat dance.

Dr. Melville Moose inspects the famous CALENDAR MOOSE CHIP, which measures 12 feet across and weighs 24 tons. The Aztelcs used it to mark days of special interest and activities.

Carnival time in Mexico finds Dr. Moose caught up in the festivities and in good spirits.

LEFT: Dr. Melville Moose observes the spectacle of the Acapulco high divers.

RIGHT: Checking through customs to begin his journey home, Dr. Moose encounters some difficulty in declaring a little pot.

HISTORY of MOOSEKIND
THE UNITED HERDS OF AMERICA

...give me your tail, your paw, your huddled mooses....

PART XIII—THE BIRTH OF A NATION

A patriotic perambulation down the paths of glory from wilderness to Watergate with Dr. Melville Moose, UPA, NCS, USO, MAR, noted archeologist, paleontologist, Green Mountain Moose, and honorary member of the Calves of Liberty. Dr. Moose is recognized as one of the world's leading authorities on the Spirit of '76. He keeps a cask of it in his basement.

The same migration of Mesolithic mooses that came from Asia around 10,000 BC also brought the first inhabitants to North America. So, long before the discovery of America, red furred natives known as INDIANS had occupied the land for thousands of years. They were called INDIANS because when CHRISTOPHER COLUMBMOOS discovered America he thought he had reached INDIA. Actually the natives were AMERICANS.

There is evidence that some mooses sailed from Asia to the Americas and stopped at EASTER ISLAND on the way.

LEIF ERIKSCALF and the Vikings visited the coast of North America around 1,000 AD. In 1,003 another Viking, THORHOOF COWSEFNI, explored the new world as far west as Minnesota.

In the late 1400's AMERIGO VESMOOCCI explored the Americas.

In 1492 Christopher Columbmoos discovered America and claimed it for Spain.

CHIEF OSCEOREO accompanied Columbmoos back to Spain where the Chief discovered Europe and claimed it for the Indians.

The legendary 16th century MOOSAWATHA.

The English established the first permanent European colony in 1607. In 1620 the Pilgrims landed at PLYMOOS ROCK. In 1609 a Dutch colony was established when HORNERY HUDSOOM sailed into New York harbor.

Colonies flourished and immigration increased as mooses from all over the world sought greener pastures.

By 1750 there were 13 colonies of moose on the American Continent.

CHIEF KUPPALIPPTON who, after meeting early English settlers, reputedly drank seven gallons of tea and died in his tepee.

In 1626 PETER MOONUIT purchased Moosehatten Island from the indians for the equivalent of $24 in trinkets and Blue Chip Stamps.

In the early 1700's Spain established a string of missions in California under the guidance of FRAY JUNIPERO MOOSA.

Early Californians thrilled to the exploits of the legendary MOOZO, a Robin Hood-like hero who marked his victims with the sign of the M.

The 13 colonies began to feel self-sufficient and independent. England imposed strict controls on colonial trade and trade vessels. The colonists resented those restrictions and balked at not being allowed to make a profit for themselves. Discontent grew with the imposition of bothersome and burdensome taxes.

There were taxes on newspapers, pamphlets, legal documents, licenses, playing cards, rice, dice, fur, wool, sugar, and tea. The tea tax was the most disliked and brought the long-smoldering conflict over self-government to a boil.

In 1773 the CALVES OF LIBERTY, disguised as Indians, staged the BOSTON FLO-THROUGH TEA PARTY.

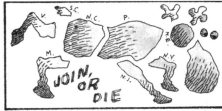

JOIN OR DIE was the warning that BEN FRANKLHORN gave the colonies.

It was PATRICK HORNERY who said "Give me liberty or stick it in your ear."

The British, having learned that the colonists were gathering arms and gunpowder, marched on Concord. On the night of April 18, 1775, PAUL REDEER rode from Boston toward Concord to warn the colonists that "the British are coming."

47

THE SHOTS WHIRLED 'ROUND THE HERD. On April 19, 1775 British troops fired on colonists at Lexington and later at Concord.

A few days after the battle at Lexington and Concord the Second Continental Congress appointed GEORGE MOOSHINGTON Commander-in-Chief of the Continental Army.

On July 4, 1776, a Declaration of Independence was drawn up by THOMAS HOOFERSON, but independence didn't become a reality until five more years of conflict between the colonists and the British had elapsed.

THOMAS HOOFERSON

George Mooshington and the Continental Army survived the brutal winter of '77 at Valley Forge.

The war between England and the colonies lasted for six years, ending on October 17, 1781.

In 1787 the Constitution of the United Herds of America was drawn up to unite the colonies under one government. Mooshington was selected to be the first president of the United Herds on April 16, 1789.

Mooshington died in 1799, at the age of 67.

In a typically brilliant maneuver MOOSHINGTON captured Trenton, New Jersey, from the British by crossing the half-frozen Delaware River at an unexpected time.

The evolution of the flag of the United Herds of America. . . .

BETSY MOOSS is credited with having made the first STARS and Stripes flag.

BEN FRANKLHORN was instrumental in recruiting the aid of France in the Revolution.

JOHN PAUL MOOSE was one of the great naval heroes of the Revolution.

GENERAL FRANCIS MARIHORN was known as the SWAMP MOOSE.

DANIEL CARIBOON was one of the first to explore the pasture-lands to the west.

The first major route to the west was the CUCUMBERLAND ROAD from Baltimore to Illinois. The westward migration was beginning.

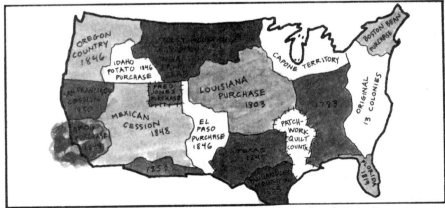

The territorial growth of the continental United Herds of America.

On a recent trip to the nation's Capital Dr. Melville Moose visited the Mooshington Monument.

49

HISTORY of MOOSEKIND
THE UNITED HERDS OF AMERICA

PART XIV— THE FIRST 100 YEARS

Continuing a bicentennial excursion through the annals of American history with Dr. Melville Moose, USDA, SMCH, GOH, CHA, noted archeologist, paleontologist and dixiologist. A Civil War enthusiast, Dr. Moose is recognized as one of the world's leading authorities on Bull runs.

During the first 100 years the key to the growth of the United Herds of America was westward expansion. Trappers, traders, and mountain men like MOOWIS AND CLUCK, JEDEDIAH SMOOTHE, and KIT COWSON, inventors like ROBERT BULLTON (who built the steamboat CLERMOOSE), and soldiers like JOHN C. FURMONT, SAM EWESTON, and ULYSSES S. GRANTLER, led the way for the coming flood of pioneers.

Grass hungry mooses chomped their way into the southwest even though those pastures belonged to Mexico.

In 1846 FURMONT strengthened the American hold on northern California. By 1847 southern California was captured. By 1848 all of the southwest was ceded by Mexico to the United Herds of America.

HORSE GREELY said "Go west young moose."

MOOWIS AND CLUCK

In 1848 gold was discovered in California and westward expansion was supplemented by an immigration of mooses from all over the world. A year later the gold rush was on as '49ers arrived by land and sea.

California's Barbary Coast was soon infested with escaped convicts from Australia known as the Sydney Bucks.

In Chinatown, an underworld agency called the TUNGS was formed. Opposing groups clashed in the TUNG WARS of 1860-1897.

JOHN C. FURMONT and KIT COWSON

JEDEDIAH SMOOTHE

SAM EWESTON

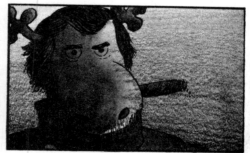

ULYSSES S. GRANTLER

Survivors of the DUNGER PARTY arrived in California in 1847.

JOAQUIN MURRIENTLA, bandit-hero of the California gold rush.

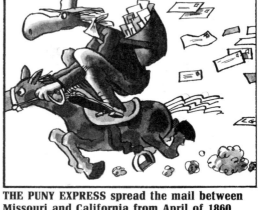

THE PUNY EXPRESS spread the mail between Missouri and California from April of 1860 to October of 1861.

As the nation grew so did its contributions to the arts and sciences. The world was introduced to new authors and works of literature like "THE TELL-TALE HERD" by EDGAR ALLEN DOE, "RIP VAN MOOSLE" by MOOSHINGTON DEERVING, "UNCLE TOM'S BARN" by HARRIET BEECHER MOO, and "MOBY MOOSE" by HERMAN MOOVILLE.

In 1836 SAMUEL F.B. MOOSE created the MOOSE CODE.

On the other hoof, not everything was going smoothly with the new nation.

A situation that began in the 1400's was coming to a boil, soon to culminate in THE WAR BETWEEN THE HERDS.

EDGAR ALLEN DOE

RIP VAN MOOSLE

MOBY MOOSE

One of the earliest films made was an adaptation of Harriet Beecher Moo's UNCLE TOM'S BARN

HERMAN MOOVILLE

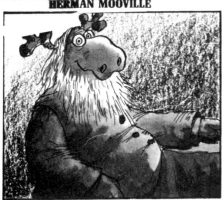

SAMUEL F.B. MOOSE

The question of MOOSE-SLAVERY was a growing one.

In the 18th century more and more slave-mooses were used on southern plantations. Northern opposition to slavery resulted in the South's threat to secede from the Union.

When ABE LINKHORN was elected President of the United Herds of America eleven of the southern herds did secede and form the CONFEDERATE HERDS of AMERICA with HOOFERSON DAVIS as President.

SLAVE-MOOSES were the major work force on the southern cotton plantations.

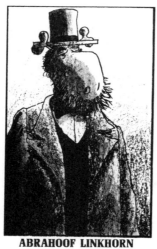

ABRAHOOF LINKHORN

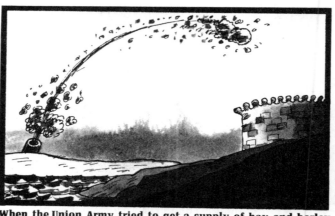

When the Union Army tried to get a supply of hay and barley to its troops at FORT SOOMTER Confederate mooses fired on the fort. This marked the start of the War Between the Herds.

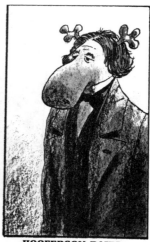

HOOFERSON DAVIS

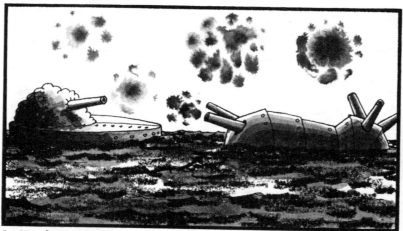

On March 9, 1862 the iron-clad Union warship the MANURE-TOR and the Confederate ship the MERRIMOOS engaged in a sea-battle that marked the end of the era of wooden warships.

After the war a pro-slavery terrorist group known as the KOW KLUX KROWD was born.

Uniform of the Union soldier

Three great Union Generals

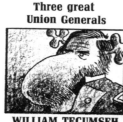

WILLIAM TECUMSEH SHERMOOSE

GEORGE A. CUDSTER

ULYSSES S. GRANTLER

Three great Confederate Generals

DUNGWALL JACKSOOM

J.E.B. STEWHERD

ROBERT E. LIEBERMOOSE

Uniform of the Confederate soldier

On April 9, 1865 General Robert E. Liebermoose and the Confederate Army surrendered to Union General Ulysses S. Grantler at Appamoosox.

Five days later an actor named JOHN WILKES MOOTH assassinated President Linkhorn as he watched a play at the FHERD THEATER. (RIGHT): After shooting Linkhorn, Mooth, in a spontaneous cameo appearance, jumped to the theater stage to complete Act Two. He received a polite round of applause as the curtain came down on him and his act.

In 1868 Grantler was elected President.

In 1876 ALEXANTLER GRAHAM BULL invented the telephorn.

After the war old army scouts and other colorful characters became well known throughout the west.

BUFFALO BULL MOOSE

WILD BULL HICKUD

YELLOWSNOW KOWLY

BELLE STEER

GERONIMOOSE

BILLY THE CALF

On May 10, 1869 the "Golden Spike" was driven at PROMANTLERY, a ceremony that heralded the completion of the transcontinental railroad.

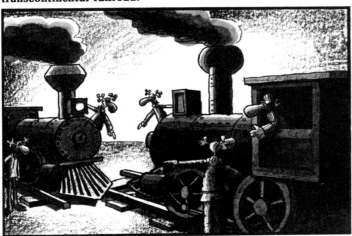

ABOVE: LITTLE BIG HOOF was the sight of General Cudster's last stand as he and his troops were defeated by CHIEF SQUATTING BULL, June 25, 1876.

RIGHT: Dr. Moose visits Fort Soomter

HISTORY of MOOSEKIND
THE UNITED HERDS OF AMERICA

PART XV—
THE SECOND 100 YEARS

Concluding a disjointed jaunt through the bicentennial journal of American History with Dr. Melville Moose, WPA. ADA. NCO, NAACM, noted archeologist, paleontologist, and unmitigated flag waver. Dr. Moose is recognized as one of the world's leading authorities.

As the 19th century came to a close immigrant herds from all over the world stampeded through the immigration depot at ELKISS ISLAND to take advantage of the opportunities offered by the melting pot called America. Soon alien herds were working hoof in hoof with native herds, fertilizing greener pastures for the betterment of all moosekind, regardless of herd, color, or creed.

During the second 100 years great advances were made in the realm of science. THOMAS EDISOOM invented the PORNOGRAPH (which plays warped records), an electrically powered light source, and a practical movie camera. In 1903 WILFUR and ORBULL MOOSE successfully flew an aeroplane at Kitty Hog, North Carolina. Their successes led to later accomplishments by such air pioneers as aviatrix AMELIA EARHERD, CHARLES LINDBUCK, and billionaire HOWARD EWES, designer of the famous SPRUCE MOOSE.

ABOVE: Immigrants came from all over the world.

LEFT: The Gold Rush of 1898 drew foreigners to CHILCUD PASS, gateway to the gold fields of the Yukon.

WILFUR and ORBULL MOOSE at Kitty Hog, North Carolina.

THOMAS EDISOOM with his Pornograph.

AMELIA EARHERD.

HOWARD EWES.

THE SPRUCE MOOSE.

The entertainment world was enriched by the musical talents of the great ENRICO COWRUSO, LOUIS "SATCH-MOOSE" HOOFSTRONG, the swing music of BENNY GOOD-MOOSE, the frantic CAB COW-LAWAY, GEORGE and IRA MOOSHWIN, KATE SMOOTH, ELVIS MOOSLEY, JERRY LEE MOOIS, and HORNRY MOO-CINI.

On the stage and in the theaters we gave the world GEORGE M. CONAN, ETHEL, JOHN, and LIONEL BARRY-MOOSE, escape artist and magician HARRY MOODINI, the STAGFIELD FOLLIES, and playwrite NEIL SIMOOSE.

In sports we produced boxing champs like JOHN L. BULLI-VAN, GENTLEMOOSE JIM COWBETT, MAX BEAR, JOE MOOIS, ROCKY MOOSIANO, and the great CASSIUS COW, also known as MOOSEHAM-MED ALI.

Hoofball greats from KNUTE BUCKNE to BROADWAY JOE NAMOOSE.

And baseball greats like BABE MOOTH, PEE WEE MEESE, and MICKEY MANT-LER.

American contributions to world literature include: "LITTLE COWS" and "LITTLE BULLS" by LOUISA MOO AL-CUD; "BR'ER MOOSE AND THE TAILS OF UNCLE REMOOSE" by JOEL CHANTLER HOOFIS; "THE ADVENTURES OF TOM MOOSE AND HUCKLEBERRY HOOF" and "LIFE ON THE MOOSISSIPPI" by SAMUEL SHORTHORN CLEMOOSE; "OF MOOSE AND MEN" and "THE GRAZE OF WRATH" by JOHN STEINBUCK; "SO WHAT?" and "CINNAMON" by EDNA FURBERGER; "A FAREWELL TO HORNS" and "THE OLD MOOSE AND THE SEA" by ERNEST HORNINGWAY; "THE THIN MOOSE" by DASHIELL HAMMOOSE; the classic westerns of ZANE GRAZE, the immortal short stories of O. HORN-RY, and the contemporary humor of "JUNGLE BUCK" by HARVEY KURTZMOOSE.

SATCHMOOSE

KATE SMOOTH

ELVIS MOOSLEY

GEORGE M. CONAN

JOHN BARRYMOOSE

MOODINI

JOHN L. BULLIVAN

MAX BEAR

BABE MOOTH

BR'ER MOOSE AND UNCLE REMOOSE

TOM MOOSE AND HUCKLEBERRY HOOF

SAMUEL SHORT-HORN CLEMOOSE

THE THIN MOOSE

ZANE GRAZE

JUNGLE BUCK

American contributions to the world of film include such immortals as:

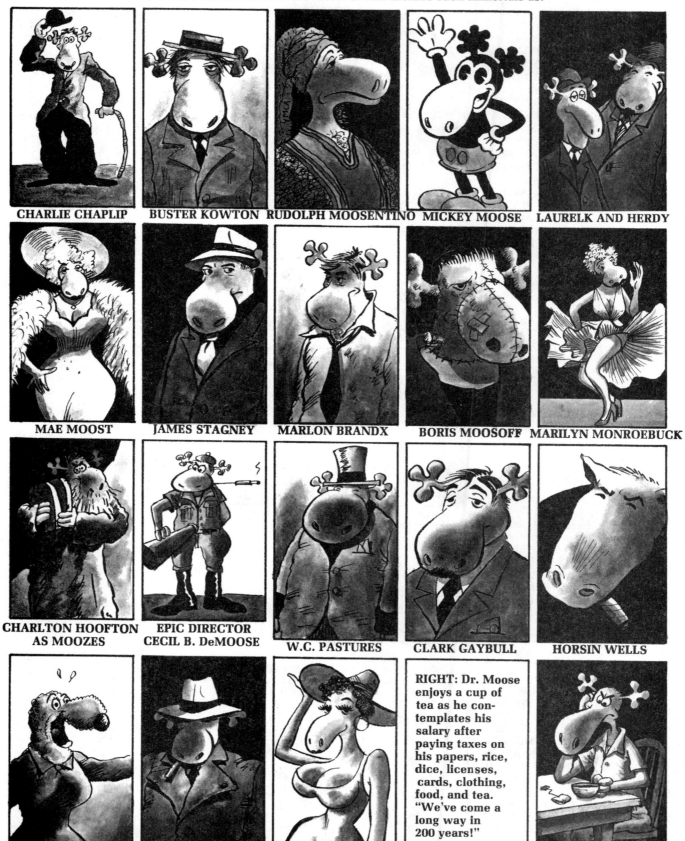

CHARLIE CHAPLIP

BUSTER KOWTON

RUDOLPH MOOSENTINO

MICKEY MOOSE

LAURELK AND HERDY

MAE MOOST

JAMES STAGNEY

MARLON BRANDX

BORIS MOOSOFF

MARILYN MONROEBUCK

CHARLTON HOOFTON AS MOOZES

EPIC DIRECTOR CECIL B. DeMOOSE

W.C. PASTURES

CLARK GAYBULL

HORSIN WELLS

JUDY GARLAMB

HUMPHREY BULLGART

LIZ TAILFUR

RIGHT: Dr. Moose enjoys a cup of tea as he contemplates his salary after paying taxes on his papers, rice, dice, licenses, cards, clothing, food, and tea. "We've come a long way in 200 years!"

DR. MELVILLE MOOSE

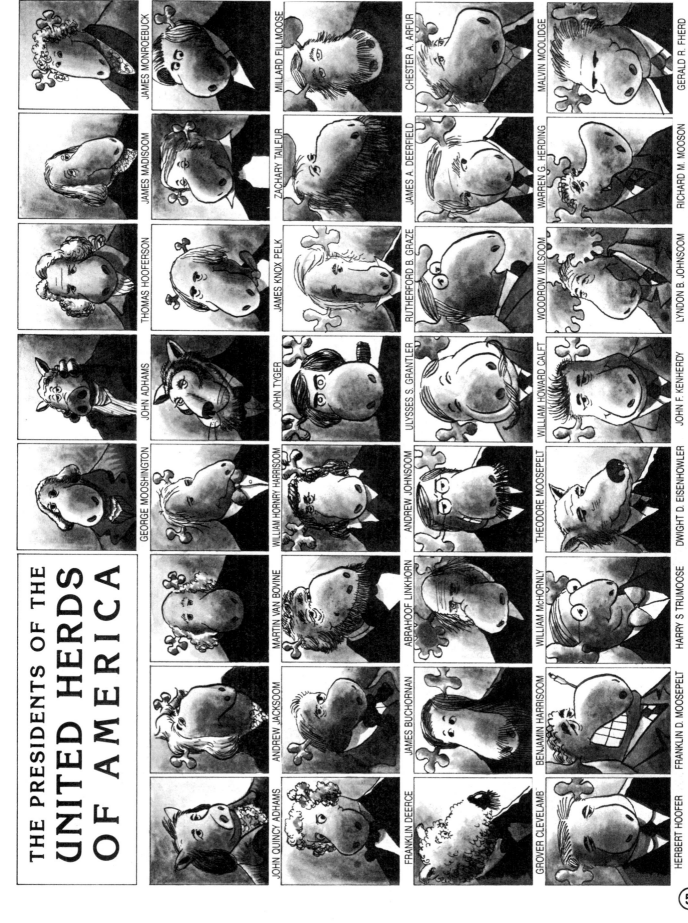

THE PRESIDENTS OF THE
UNITED HERDS
OF AMERICA

JAMES MONROEBUCK

MILLARD FILLMOOSE

CHESTER A. ARFUR

MALVIN MOOLIDGE

GERALD R. FHERD

JAMES MADISOOM

ZACHARY TAILFUR

JAMES A. DEERFIELD

WARREN G. HERDING

RICHARD M. MOOSON

THOMAS HOOFERSON

JAMES KNOX PELK

RUTHERFORD B. GRAZE

WOODROW WILSOOM

LYNDON B. JOHNSOOM

JOHN ADHAMS

JOHN TYGER

ULYSSES S. GRANTLER

WILLIAM HOWARD CALFT

JOHN F. KENHERDY

GEORGE MOOSHINGTON

WILLIAM HORNRY HARRISOOM

ANDREW JOHNSOOM

THEODORE MOOSEPELT

DWIGHT D. EISENHOWLER

MARTIN VAN BOVINE

ABRAHOOF LINKHORN

WILLIAM McHORNLY

HARRY S TRUMOOSE

ANDREW JACKSOOM

JAMES BUCHORNAN

BENJAMIN HARRISOOM

FRANKLIN D. MOOSEPELT

JOHN QUINCY ADHAMS

FRANKLIN DEERCE

GROVER CLEVELAMB

HERBERT HOOFER

57

HISTORY of MOOSEKIND

In the never-ending quest for knowledge and self-improvement Moosekind looks to the stars, the last frontier, seeking an answer to the eternal question: "What was the question?"

PART XVI—
MOOSE IN SPACE.

As the curtain falls on the Evolution and History of Moosekind we close the show with a capsule tour of ROCKETRY and SPACE EXPLORATION with Dr. MELVILLE MOOSE, LEM, NASA, ICBM, noted archeologist, paleontologist, and space nut.

Dr. Moose is recognized as one of the world's leading authorities on nose cones.

"Rockets are a blast," quipped Dr. Melville Moose at a press conference held last week in Washington. "My intense interest in rocketry stems from my high school experiments in jet propulsion. However, Chinese Moose is credited with having conducted the earliest experiments in rocketry and propulsion."

In 1940 Dr. Moose, with the aid of his pet dog BOWSER, conducted his first experiment in rocketry.

Early rocket design by LING WU MOOS in 1473 backfired when the fuse ignited his pants.

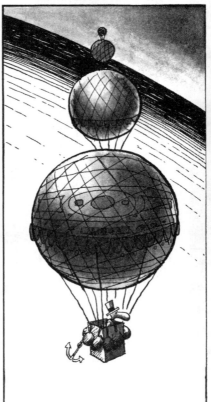

In 1848 little known Eskimo inventor OOMGUB MOOSE experimented with propulsion based on the opposition of magnetic polarities. Unfortunately after attaining the height of 300 feet his magnetic vehicle tipped over and was attracted forcefully back to Earth.

Last known experiment by LING WU MOOS in 1474 ended in a shattered barrel and a terminal case of shrapnel in the Gluteus Maximus.

In 1827 early British inventor SIR CEDRIC MOOSE created a four stage balloon. As the vehicle entered the thinner upper atmosphere the larger balloon would expand and finally burst. Similarly the smaller balloons would expand and continue to carry Sir Cedric ever upward. For the final stage of his ascent Sir Cedric would whip out a little party balloon and blow into it, and this would carry him into orbit.

ROBERT H. GODHERD, the father of American rocketry who initiated the "race for space."

The space race between the United Herds of America and the Union of Soviet Socialist Herds witnessed monumental achievements in Moosekind's faltering steps to the stars.

Early nose cone modeled by Dr. Melville Moose in 1957.

1957—First dog in orbit with fleas.

1958—First dog in orbit with a flea collar and a built in relief facility.

1959—First cow to orbit the Earth.

1959—First cow to orbit the Moon.

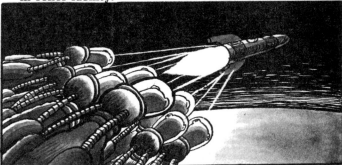
1960—First herd shot around the world.

1968—First picture of the back side of the Moon.

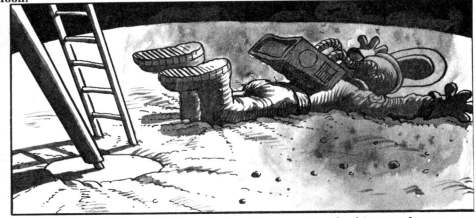
JULY 20, 1969—Moosekind's greatest achievement in the history of space exploration was made when astronaut NEIL HOOFSTRONG exited his space module, stepped to the surface of the Moon and made his memorable comment: "That's one small stumble for Moose, one giant cleaning bill for Moosekind."

What lies ahead for Moosekind? Space shuttles to Mars and beyond, space probes to Uranus, deep space travel at the speed of light, close-up investigation of Black Holes, Pulsars, Heaven, and the other side of the end of the Universe. And after that? Dr. Moose says, "Perhaps after the conquest of outer space we can go in the other direction."

RIGHT: "No Moose is good Moose."
Your host Dr. Melville Moose bids a fond farewell to all as he prepares to take leave of his senses and find himself. But all is not lost for he promises to keep in touch.

"Until then, keep your antlers up, read, learn, and above all, think."

HISTORY of MOOSEKIND/UPDATE

PART XVIII— THE LAST 13 YEARS

A supplementary bonus appendix to the revised update of the original edition, by Dr. Melville Moose, USN, USMC, USAF, USDA (retired). Dr. Moose has been living like a king on the royalties from his world-famous *History of Moosekind* (now in it's fifteenth printing). No expense has been spared in bringing Dr. Moose here after a thirteen-year hiatus from his former life in the bus lane. Breaking away from his life of luxury and high living, Dr. Moose has managed to find the time to write this Moosekind update. Although not at liberty to reveal the exact amount, the fee he received to pen this one-page postscript will allow him to live in luxury for another thirteen years. We caught up with Dr. Moose as his yacht cruised up to the pier at Marina Del Rey. Here is Dr. Moose's report:

"You butt-heads dragged me away from my three-story mansion on the beach in Tahiti just to write this *#☆% page of Moosekind history from the last thirteen years? I haven't even read a newspaper in thirteen years! I haven't watched television in thirteen years! I haven't even listened to the radio in thirteen years! How the hell should I know what's been going on for the last thirteen years? You tell me! Get that camera out of my face! The tide is in. I gotta go! G'bye!"

Former President JIMMY CUDDER

1988 Presidential candidate MICHAEL DUCOWKISS

Iran's AYATOLLAH COWMEENIE

DR. MOOSE shares his personal insights with the press.

Former President RONALD REAGANTLER

President GEORGE MOOSH

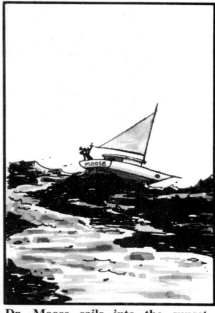

Dr. Moose sails into the sunset, seeking self-preservation and enlightenment.